20 WAYS TO DRAW A TULIP

AND 44 OTHER FABULOUS FLOWERS

LISA CONGDON

A Sketchbook for Artists, Designers, and Doodlers

 Brimming with creative inspiration, how-to projects, and useful information to enrich your everyday life, Quarto Knows is a favorite destination for those pursuing their interests and passions. Visit our site and dig deeper with our books into your area of interest: Quarto Creates, Quarto Cooks, Quarto Homes, Quarto Lives, Quarto Drives, Quarto Explores, Quarto Gifts, or Quarto Kids.

© 2014 by Quarry Books

First Published in 2014 by Quarry Books, an imprint of The Quarto Group, 100 Cummings Center, Suite 265-D, Beverly, MA 01915, USA. T (978) 282-9590 F (978) 283-2742 QuartoKnows.com

All rights reserved. No part of this book may be reproduced in any form without written permission of the copyright owners. All images in this book have been reproduced with the knowledge and prior consent of the artists concerned, and no responsibility is accepted by producer, publisher, or printer for any infringement of copyright or otherwise, arising from the contents of this publication. Every effort has been made to ensure that credits accurately comply with information supplied. We apologize for any inaccuracies that may have occurred and will resolve inaccurate or missing information in a subsequent reprinting of the book.

Quarry Books titles are also available at discount for retail, wholesale, promotional, and bulk purchase. For details, contact the Special Sales Manager by email at specialsales@quarto.com or by mail at The Quarto Group, Attn: Special Sales Manager, 100 Cummings Center, Suite 265-D, Beverly, MA 01915, USA.

ISBN: 978-1-59253-886-7

Digital edition published in 2014
eISBN: 978-1-61058-933-8

Library of Congress Cataloging-in-Publication Data Control Number: 2013942053
Design: Debbie Berne

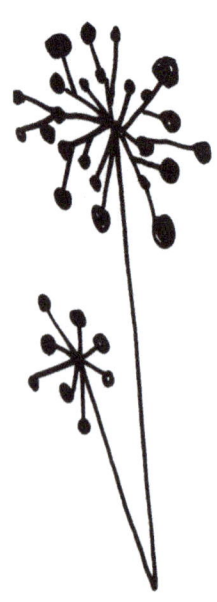

CONTENTS

Introduction 4

Draw 20 ...
Tulips 6
Daffodils 8
Ginger Blossoms 10
Dahlias 12
Roses 14
Daisies 16
Lavender Plants 18
Orchids 20
Pansies 22
Chrysanthemums 24
Irises 26
Marigolds 28
Hollyhocks 30
Poppies 32
Sunflowers 34
Pitcher Plants 36
Cherry Blossoms 38
Lotus Flowers 40
Heather 42
Maypops 44
Honeysuckle 46
Cactus Flowers 48
Protea 50
Geraniums 52

Morning Glories 54
Clovers 56
Lillies 58
Horse Nettle 60
Bleeding Hearts 62
Indian Blankets 64
Asters 66
Gladiolus 68
Thistle 70
Cone Flowers 72
Bluebells 74
Strawberry Plants 76
Dandelions 78
Wax Plants 80
Foxgloves 82
Pomegranate Flowers . 84
Billy Buttons 86
Frangipani 88
Birds of Paradise 90
Ranunculus 92
Freesia 94

About the Artist 96

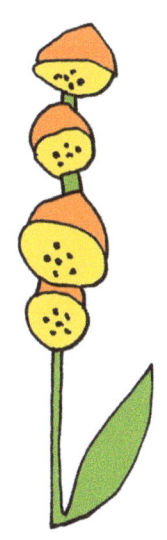

INTRODUCTION

There are few things more universally loved than flowers. They are delicate, beautiful, and filled with interesting detail. And when it comes to drawing them, your options are endless. Like other things in nature, most flowers have a geometric quality and a naturally balanced composition, so rendering them can be a really enjoyable and inspiring experience. I have been drawing flowers for as long as I have been an artist. I am particularly fond of drawing them in a more abstract (less realistic) way and then clustering them together into patterns. Drawing flowers might just be one of my favorite pastimes, so I am thrilled to have made this book!

20 Ways to Draw a Tulip shows examples of twenty different ways to draw forty-five different flowers from around the world. The flower drawings in this book range from very simple to relatively complex. They also span a wide range of styles—from abstract, to modern, to realistic. I hope you will see many that motivate you to try to draw your own designs, too.

It may be important to rethink your conception of what it means to "draw" for this book. Traditionally, we think of drawing as taking pencil or pen to paper and rendering an exact likeness of something, with perfect shading and line work. That kind of drawing practice is useful, indeed. But, for the purposes of this book, let's think of drawing as simple line drawings—distinct straight and curved lines and dots placed against a plain background. I drew all of these flowers with fine-tipped black pens on white paper. I recommend buying a few different kinds of pens at your local art store and playing around with them until you find one or two that you like best.

HOW TO USE THIS BOOK

As you turn the pages of this book and notice each of the flowers, you will see that the drawings for each flower type are either spread across two pages or clustered together on one page. For those flower types that are spread across two pages, I have left room for you to draw your own flower close to each example. For those that are clustered together on one page, you can use the space on the opposite side to draw as many of the flowers as you like.

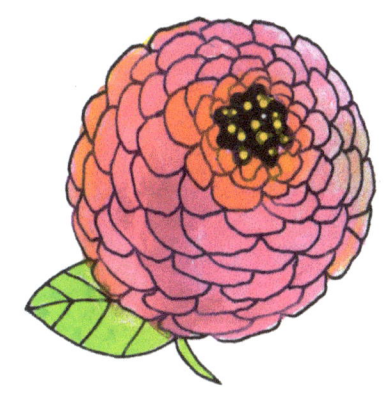

When I am trying to draw something with lines, I like to think about the basic forms, which are basically circles and lines. When examining a drawing of a flower, you might ask yourself, "How many lines and circles do I see here?" You might break down the elements of a flower. "What shape are the petals? Is the flower symmetrical? How can I render the stamen on the interior of the flower? Do I want the stem to appear straight or crooked? Are the leaves perfectly uniform or slightly askew?" Remember that there are so many quirks in nature, and including those quirks in your drawings makes them much more interesting!

If you are new to drawing, copying can be a really great way to learn to render shape and form and communicate texture and depth. That said, copying might also feel frustrating when you don't get it "just right." So don't be too hard on yourself! Perfection is not the key here. If it helps to begin by using a pencil with an eraser (and not a pen) to practice, that is fine, too. The point is not to copy each flower exactly, but to get a likeness, to experiment, and to have fun!

I hope you enjoy this book very much!

dahlia: gouache paint
poppy: colored pencil
daisy: marker

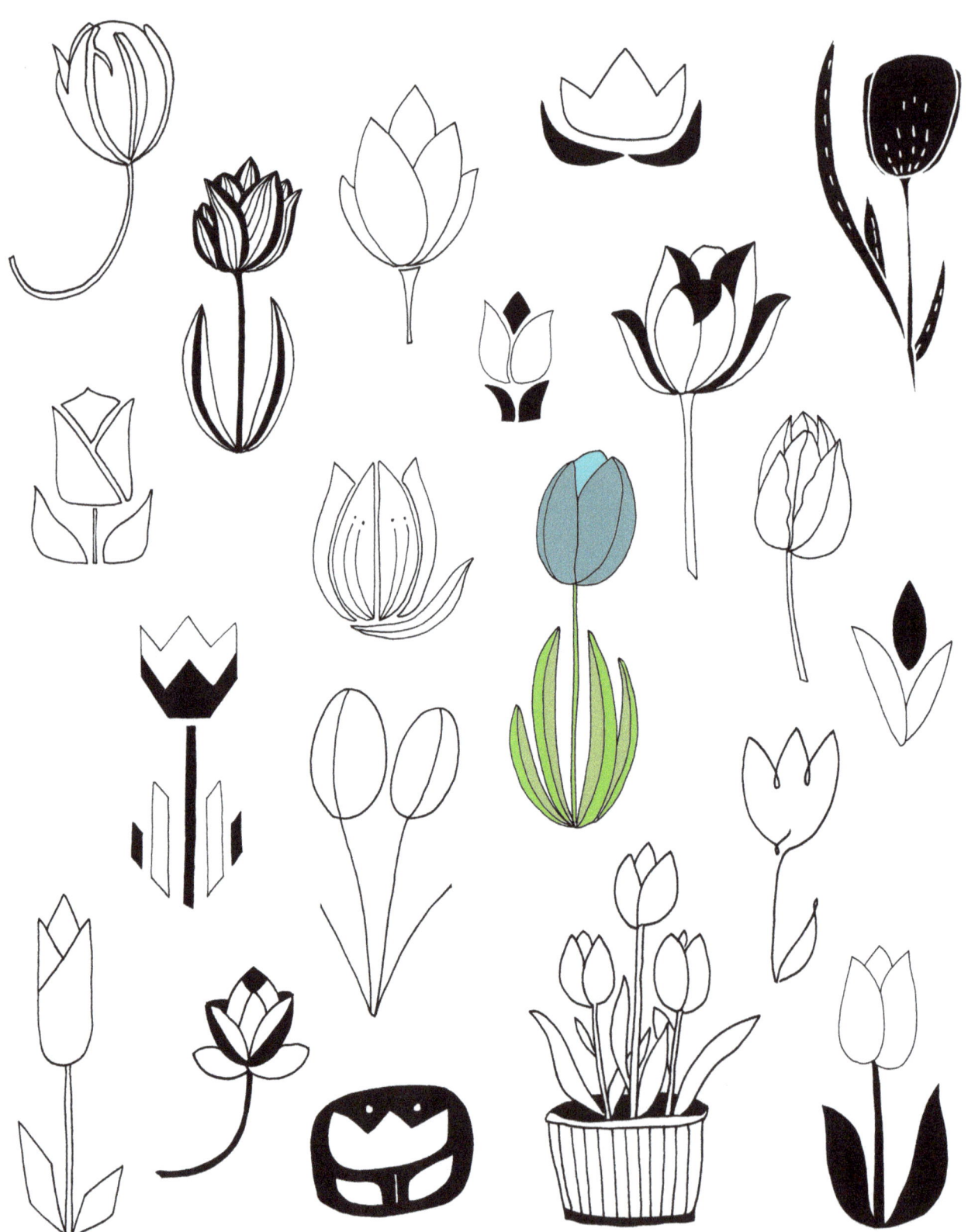

DRAW 20
Tulips

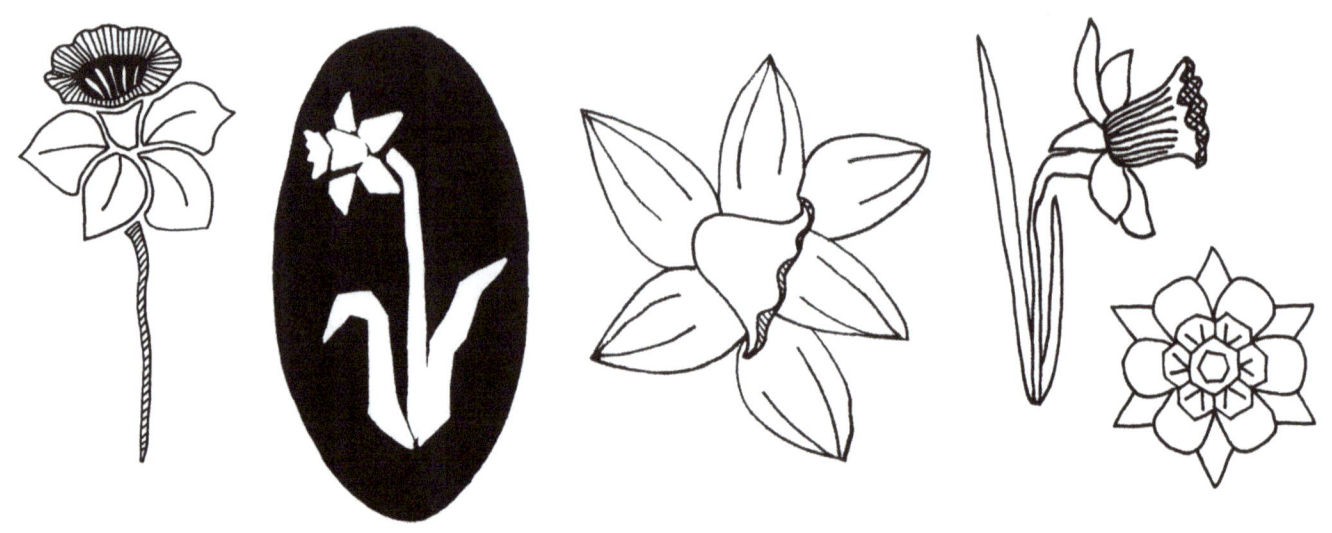

DRAW 20
DAFFODILS

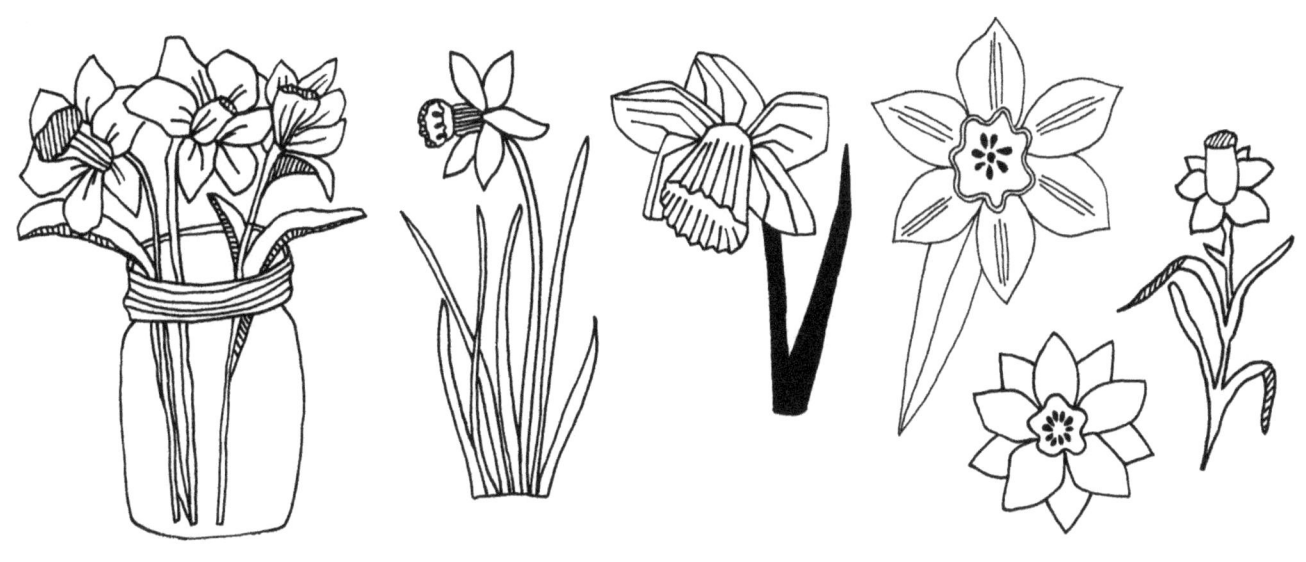

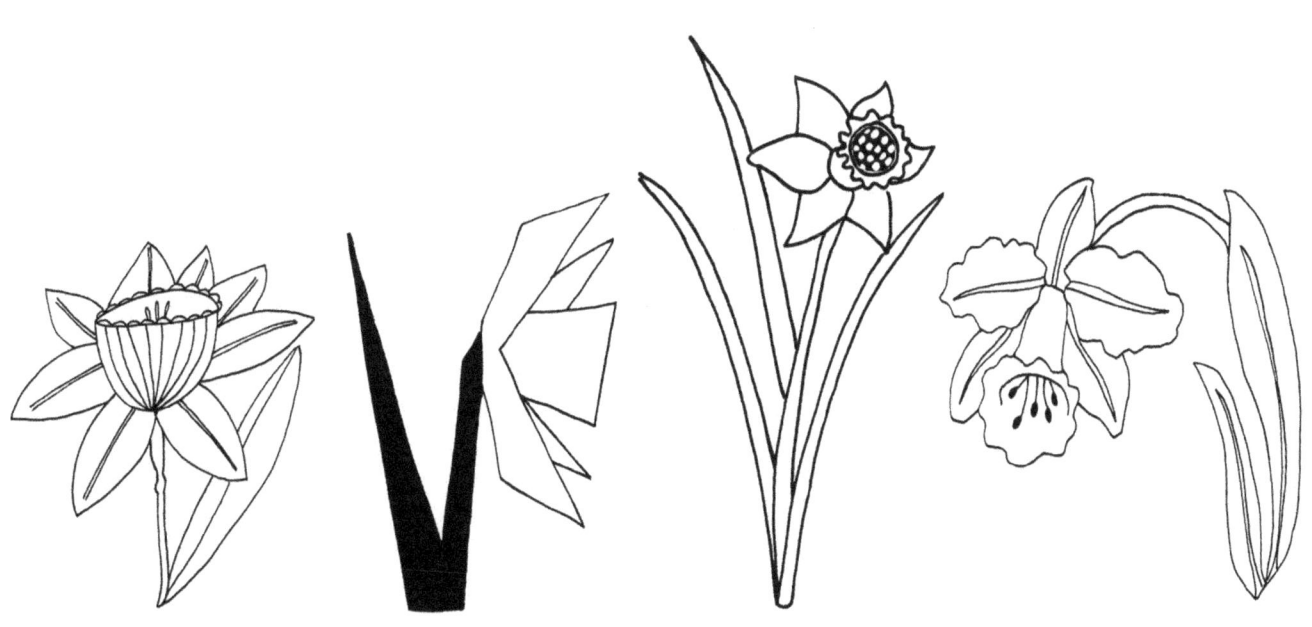

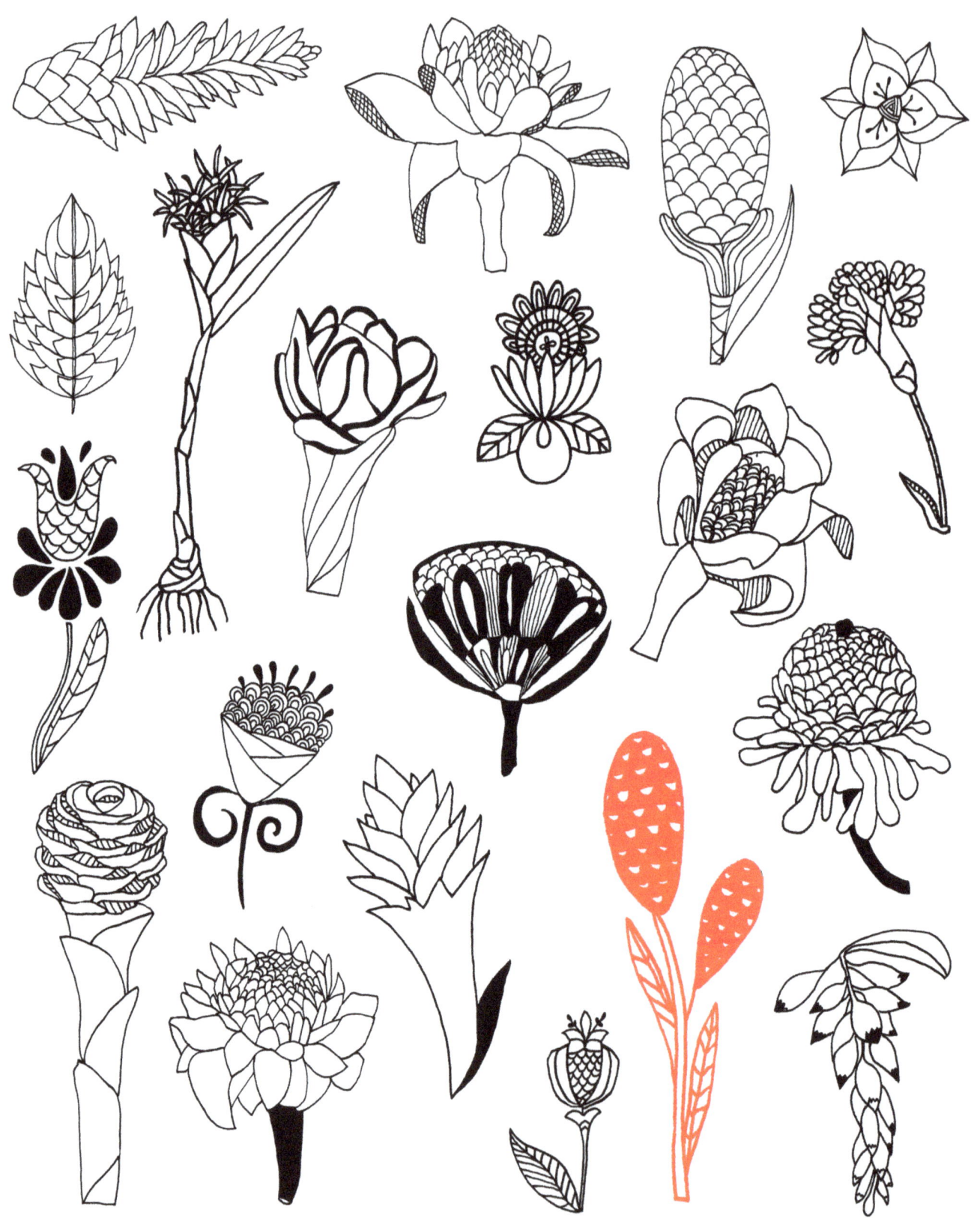

DRAW 20
Ginger Blossoms

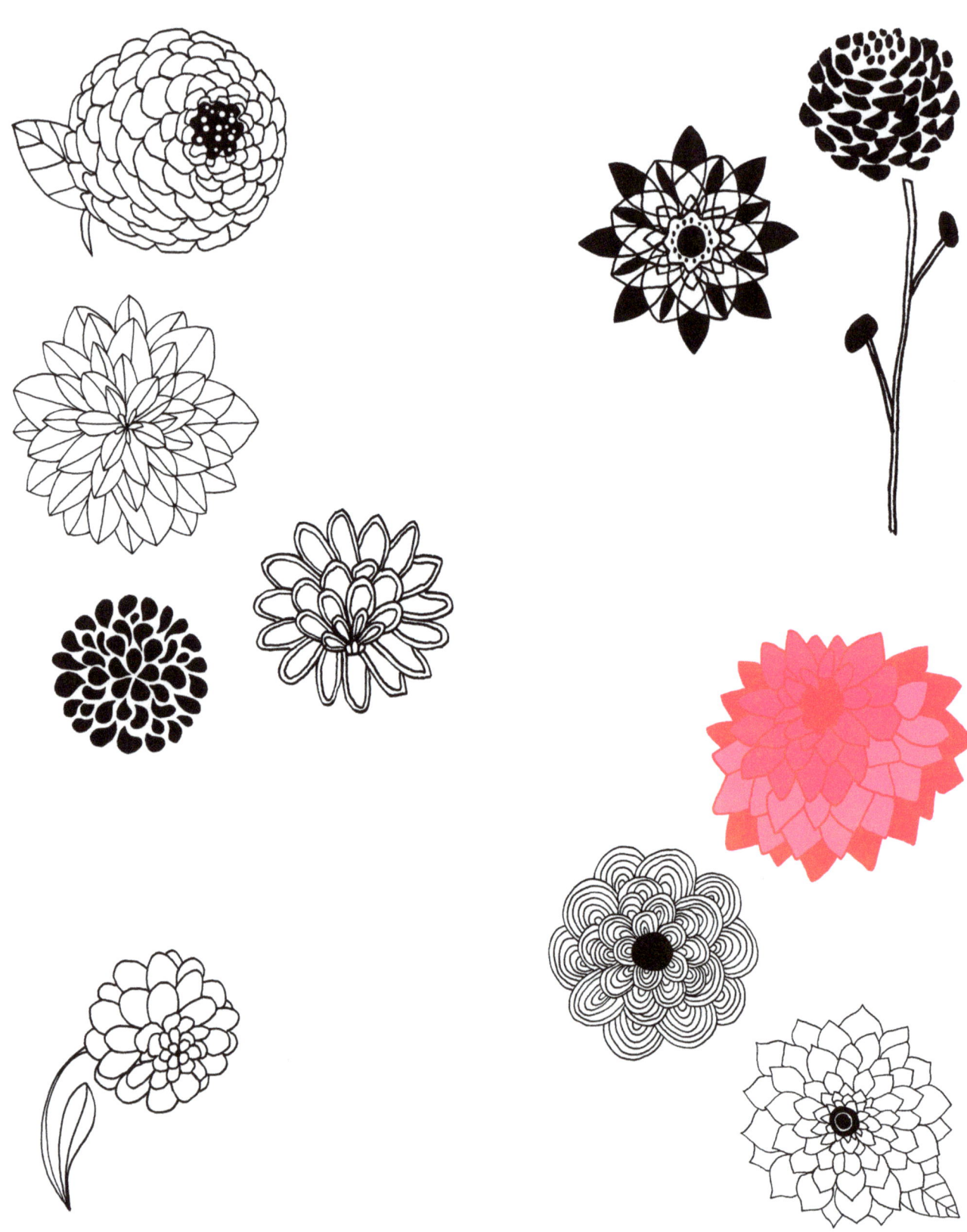

DRAW 20 *Dahlias*

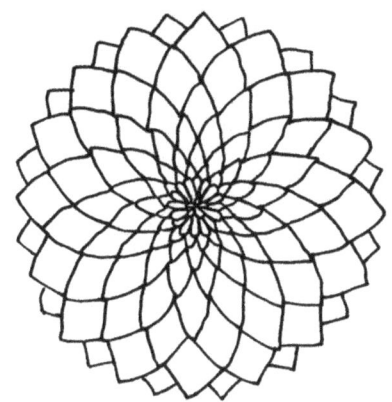
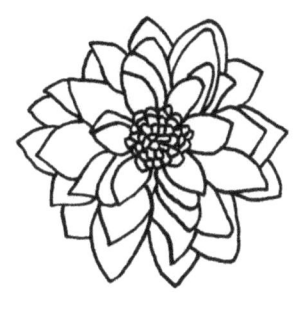

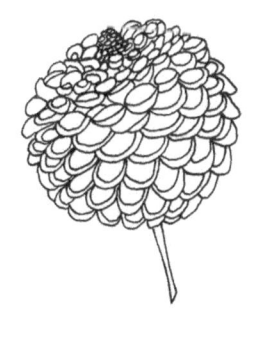
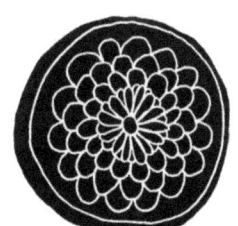
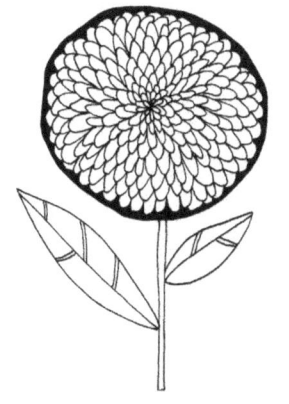
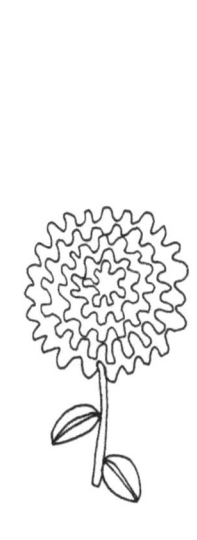
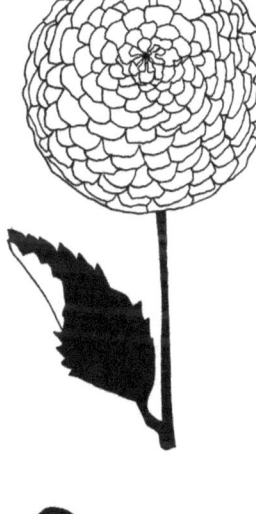
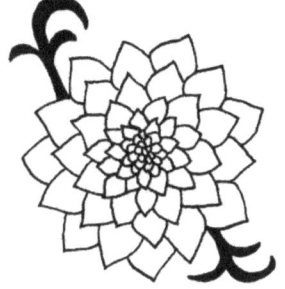

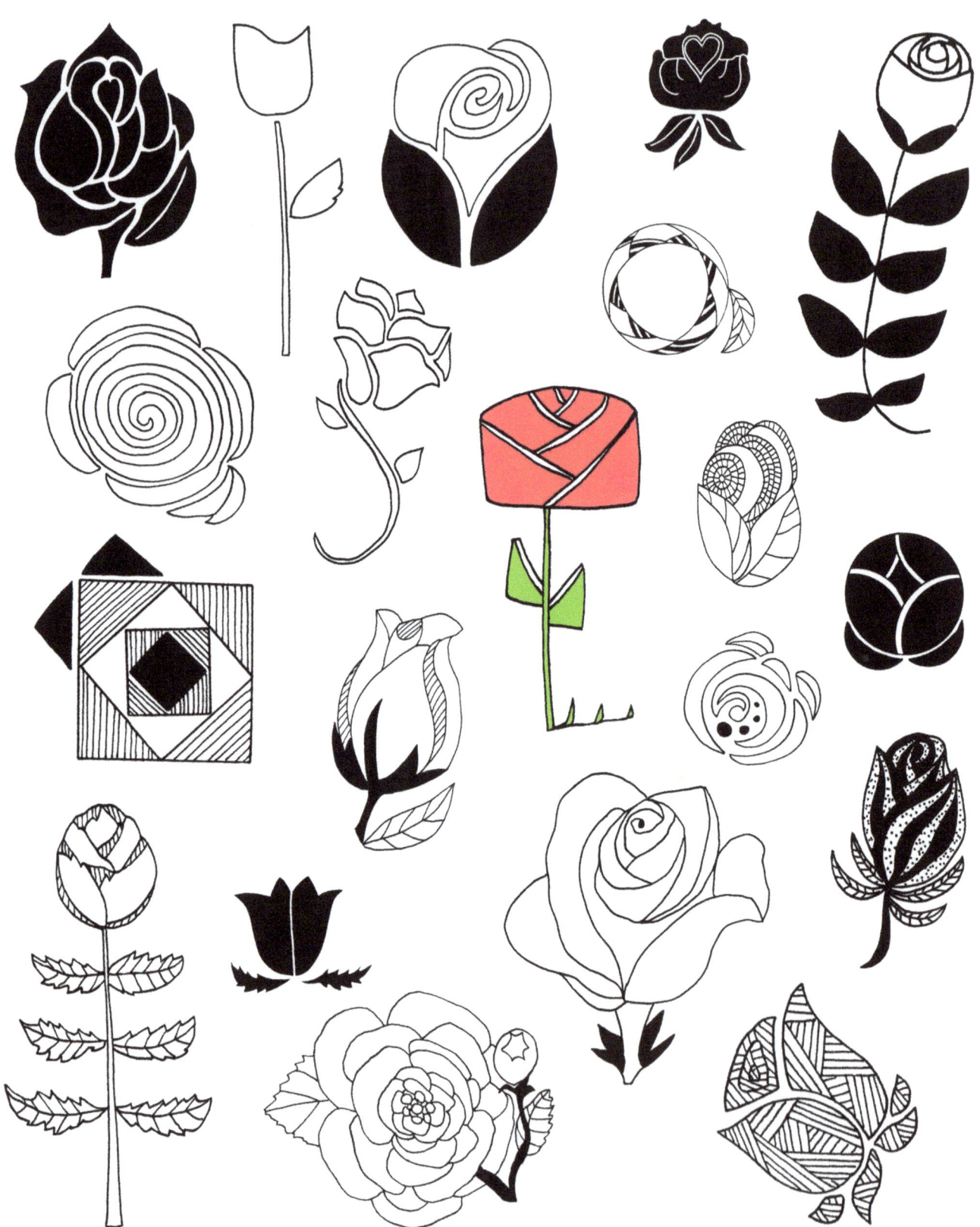

DRAW 20
Roses

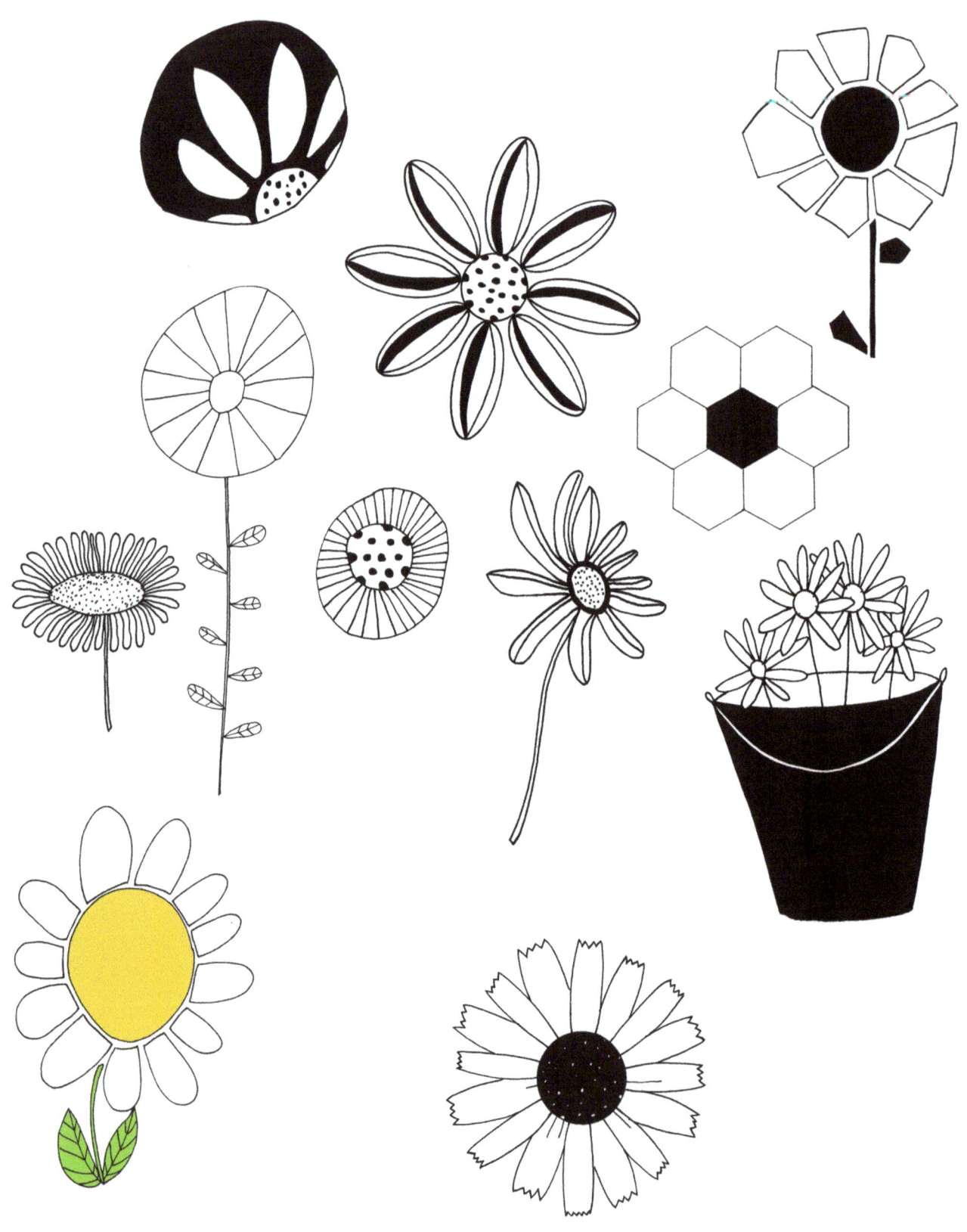

DRAW 20
DAISIES

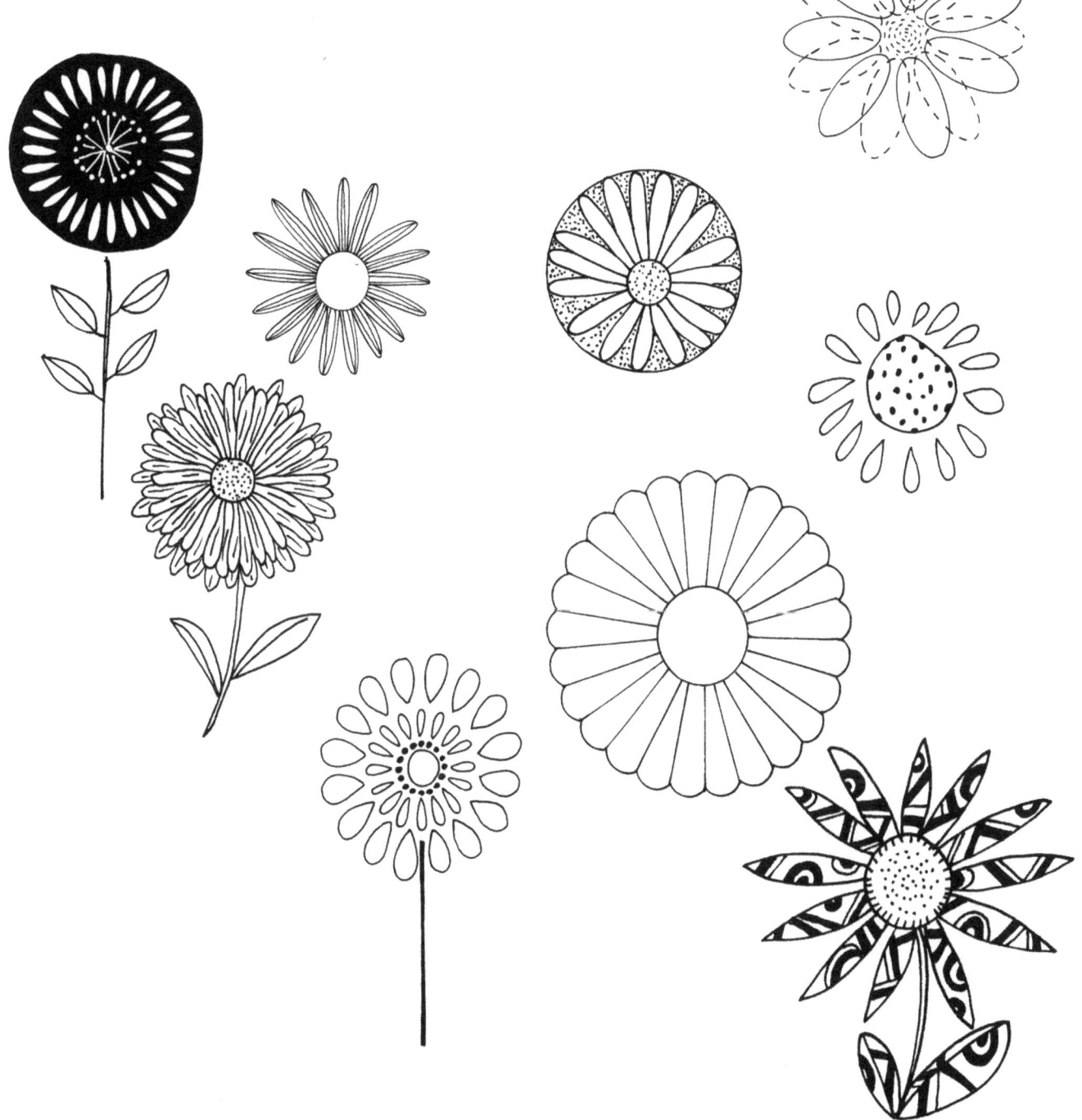

DRAW 20
Lavender Plants

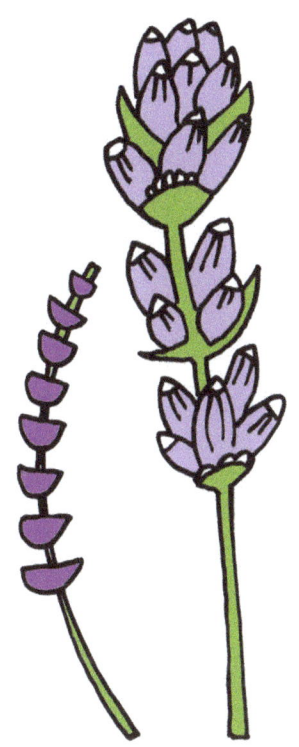
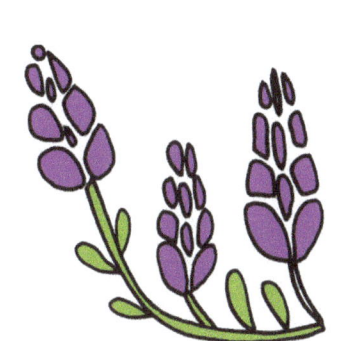

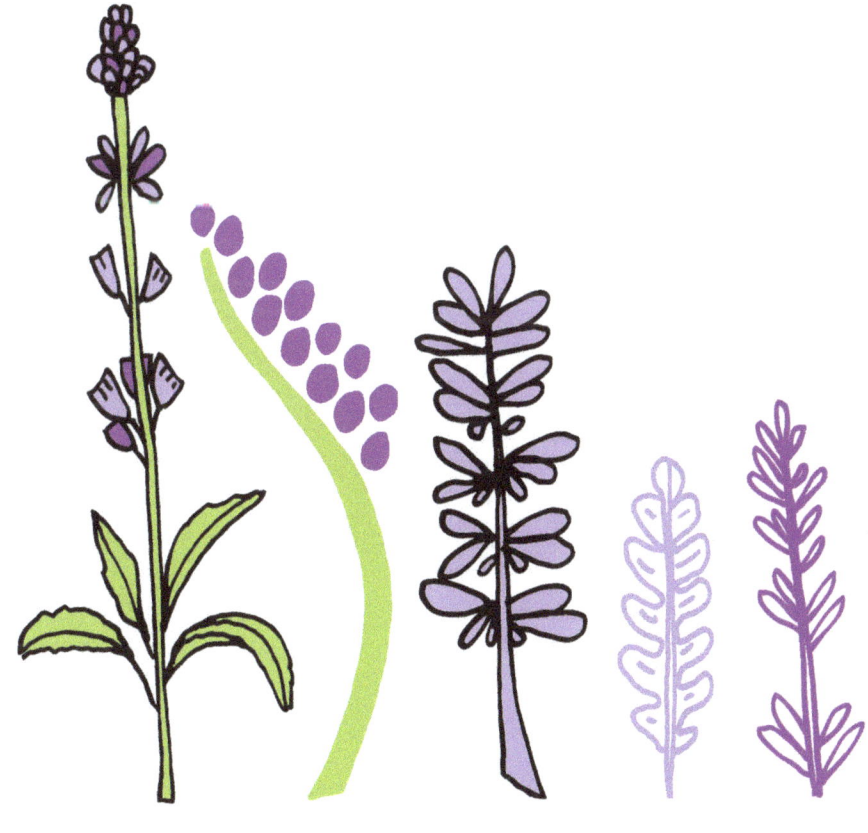

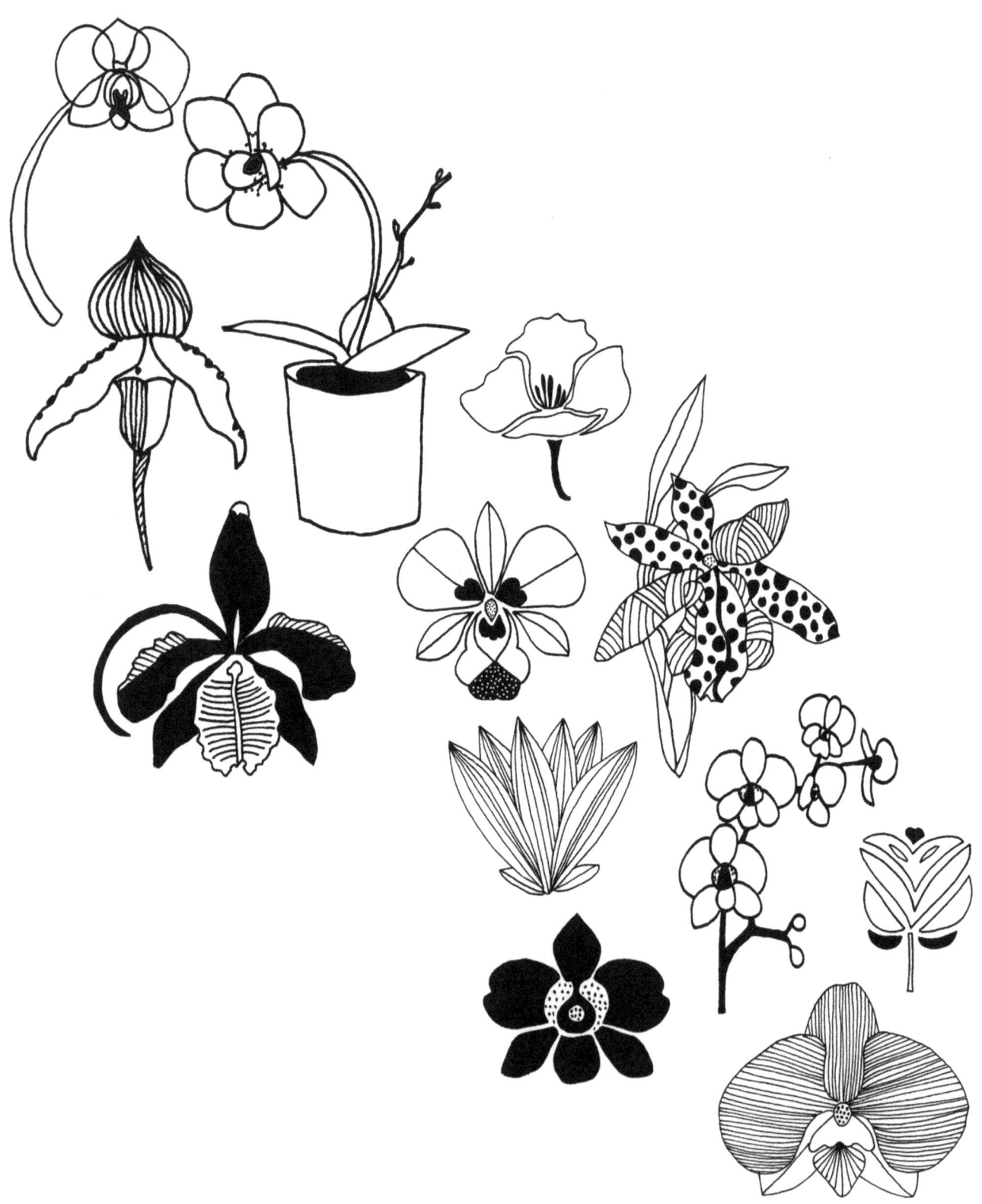

DRAW 20 Orchids

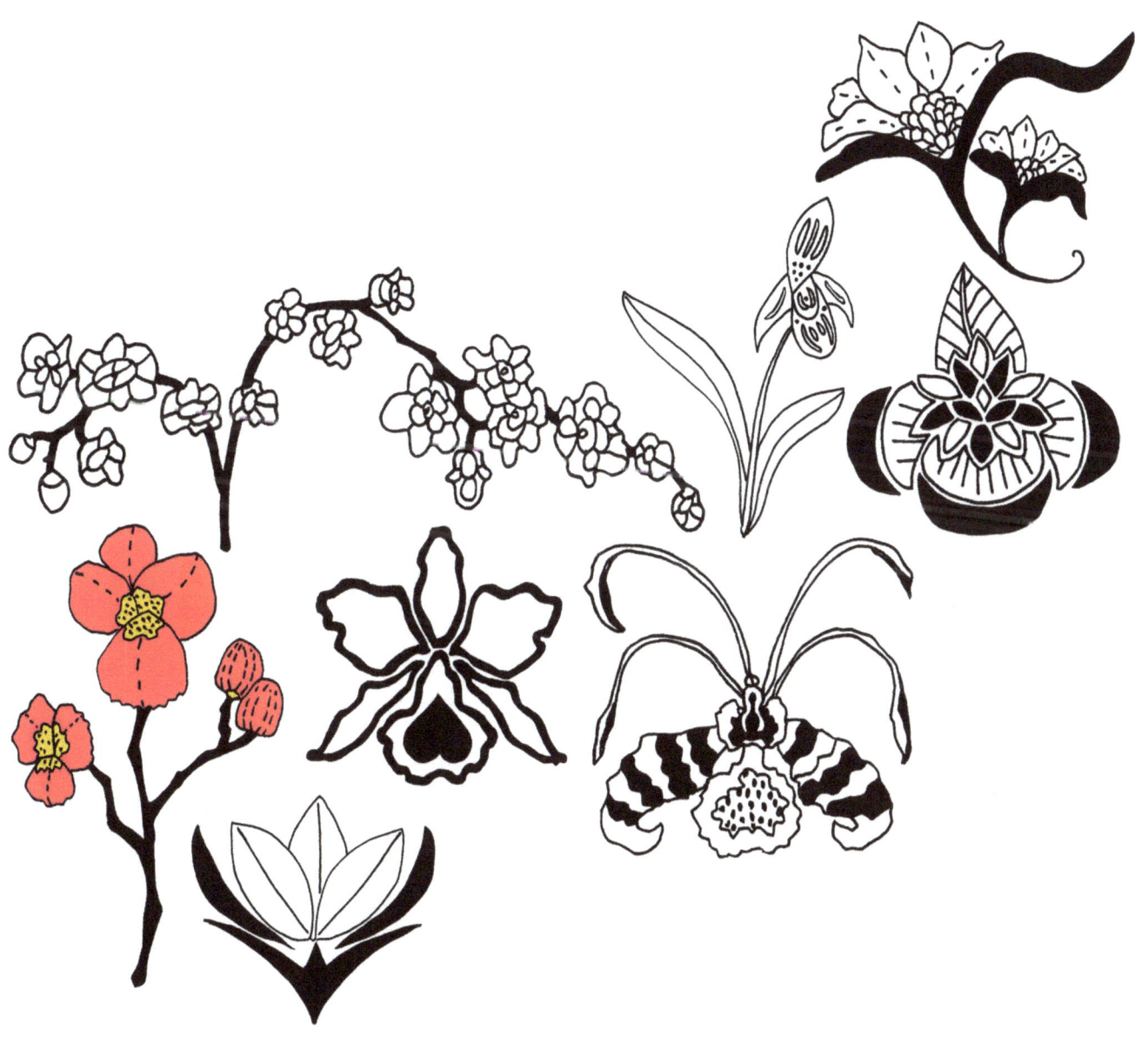

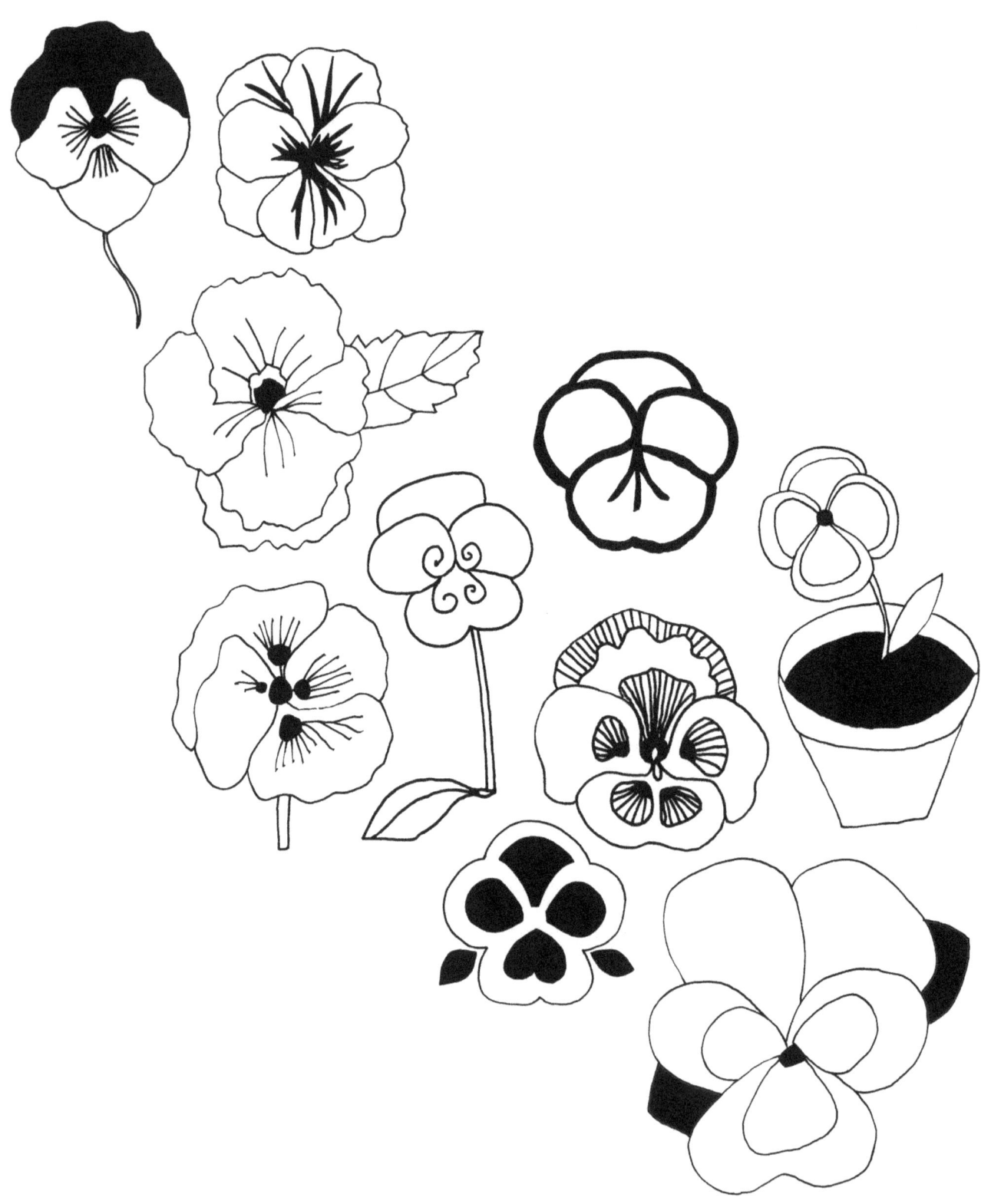

DRAW 20
Pansies

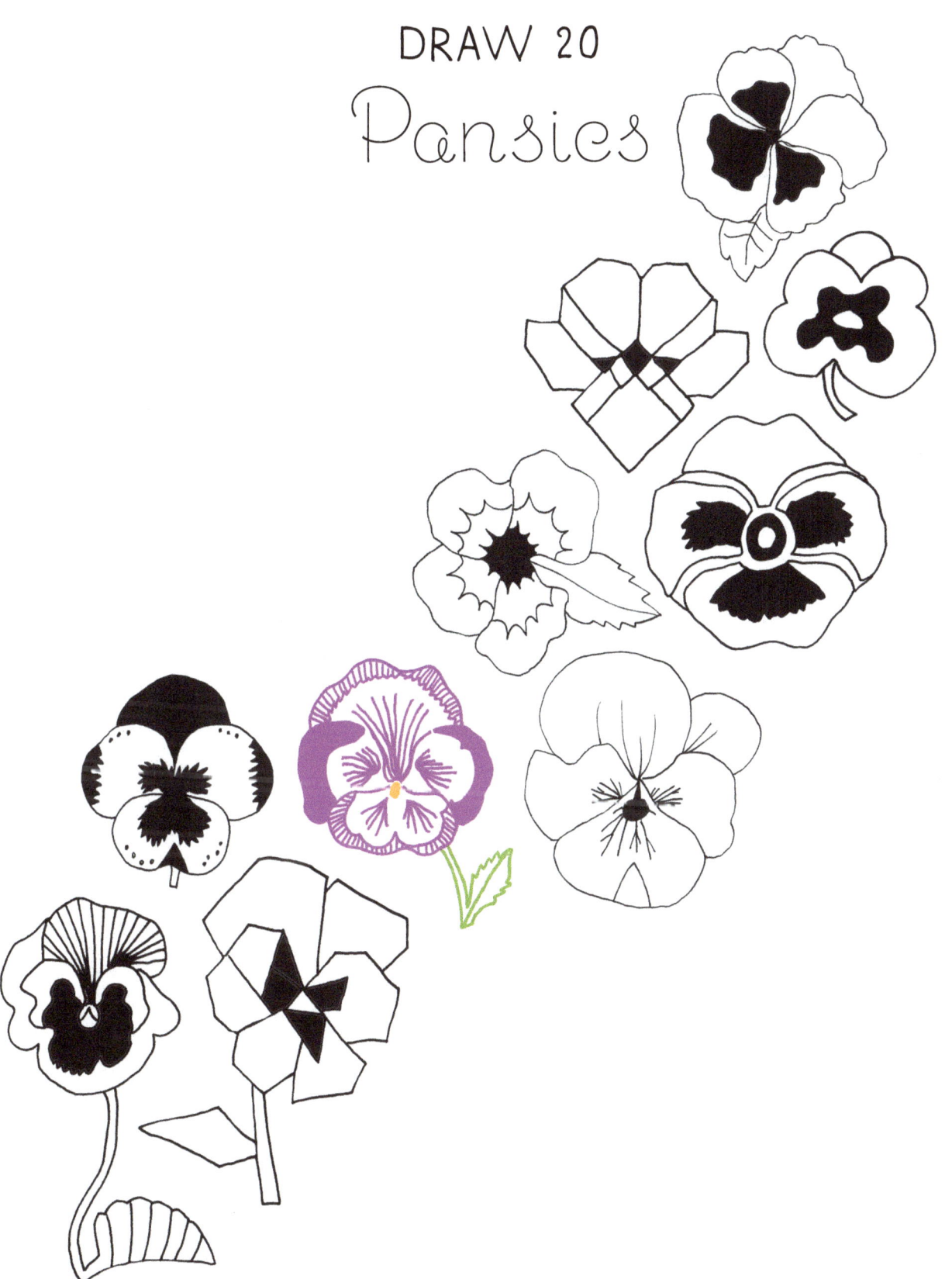

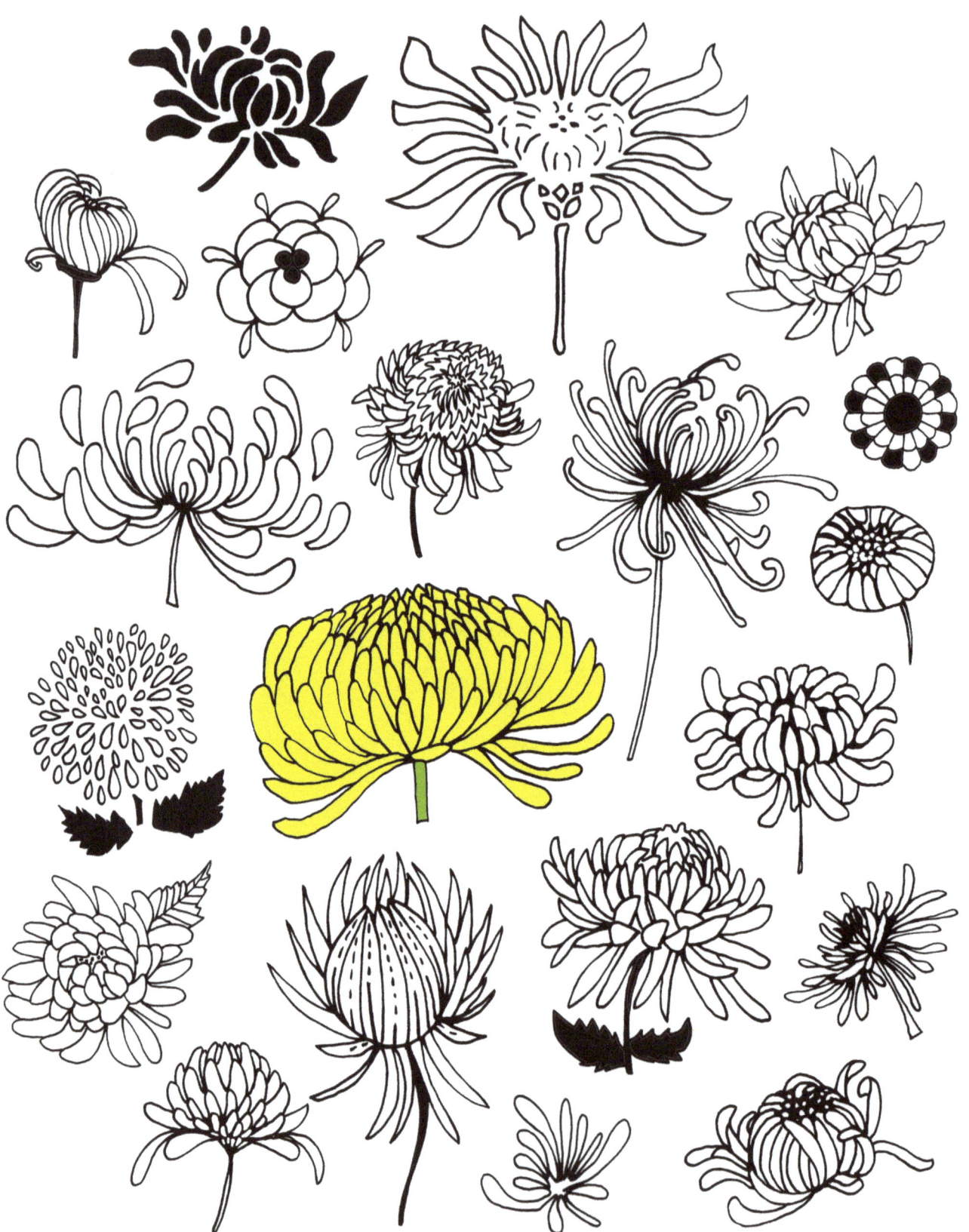

DRAW 20
Chrysanthemums

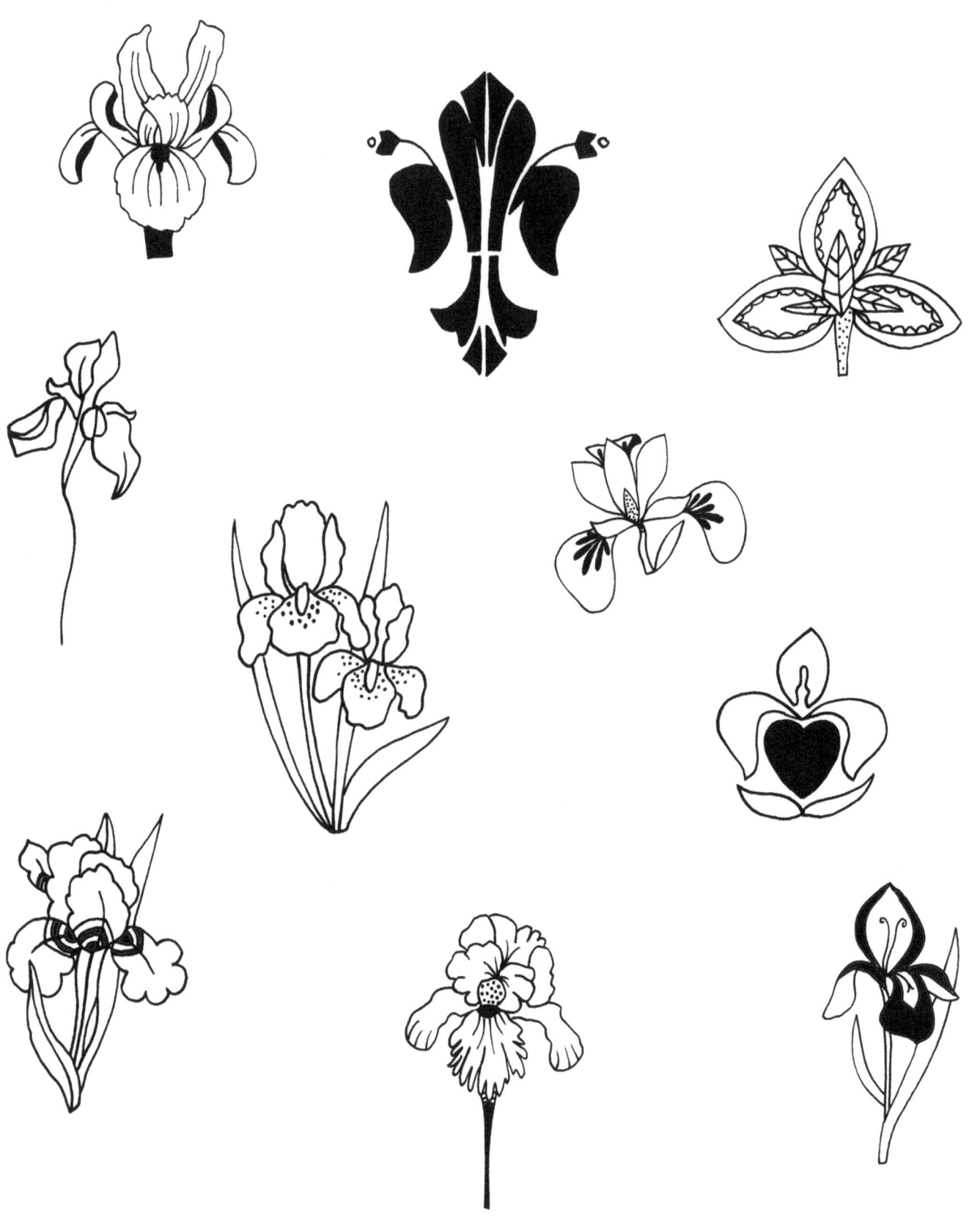

DRAW 20 Irises

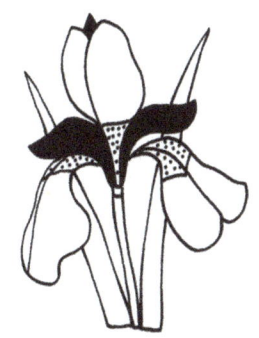

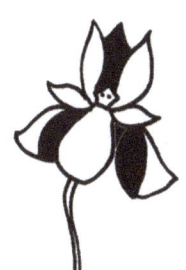
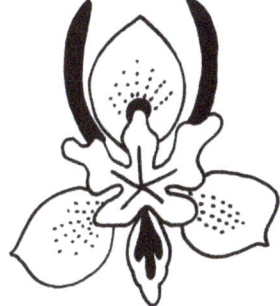
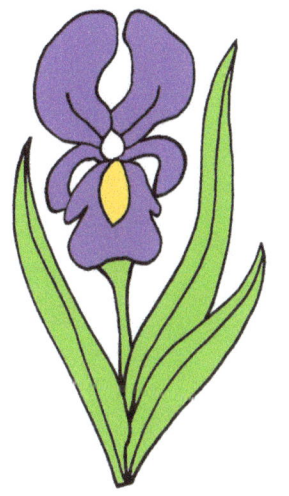

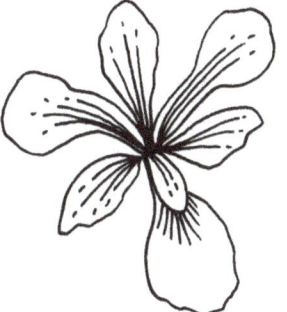
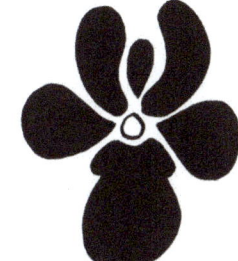

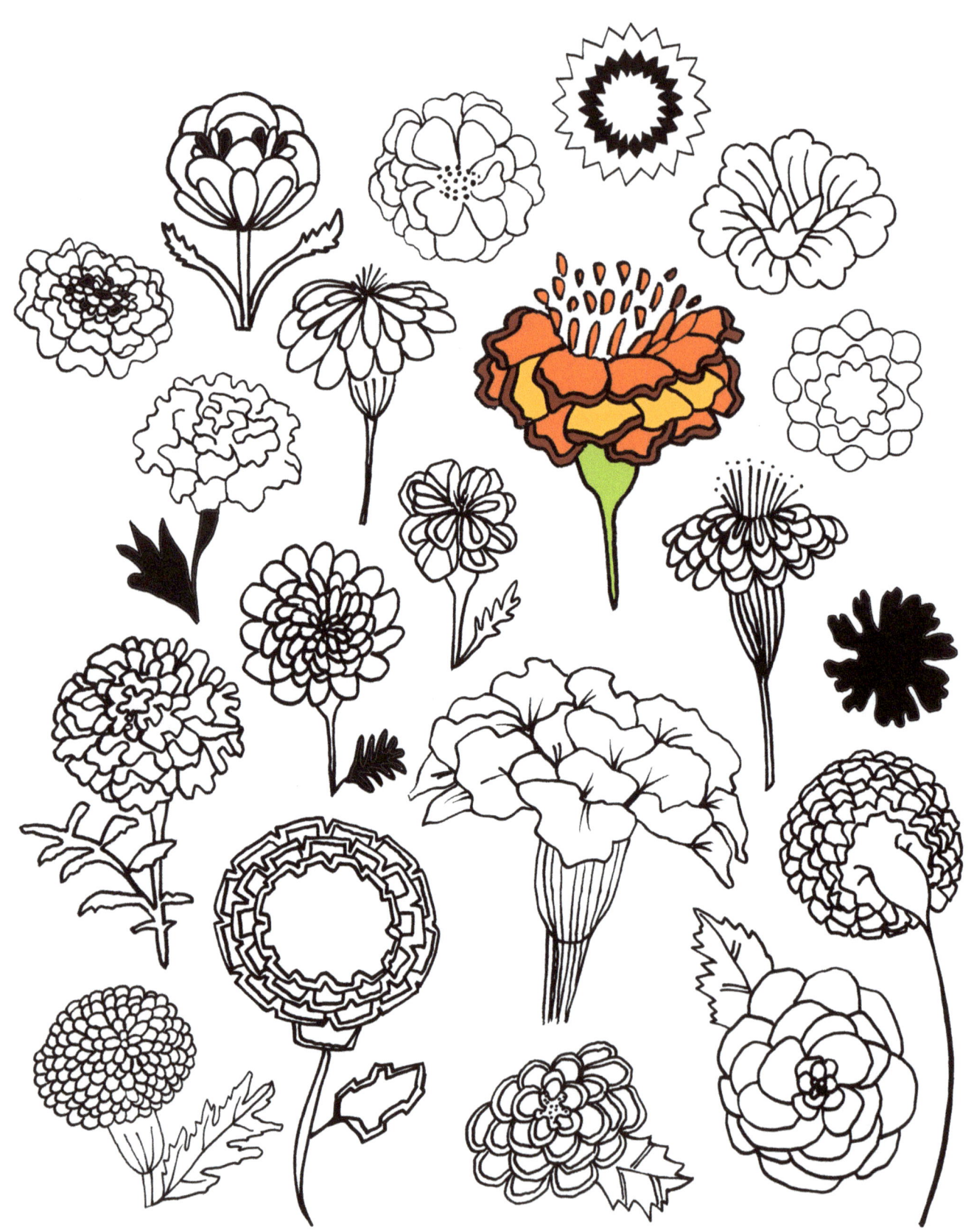

DRAW 20
Marigolds

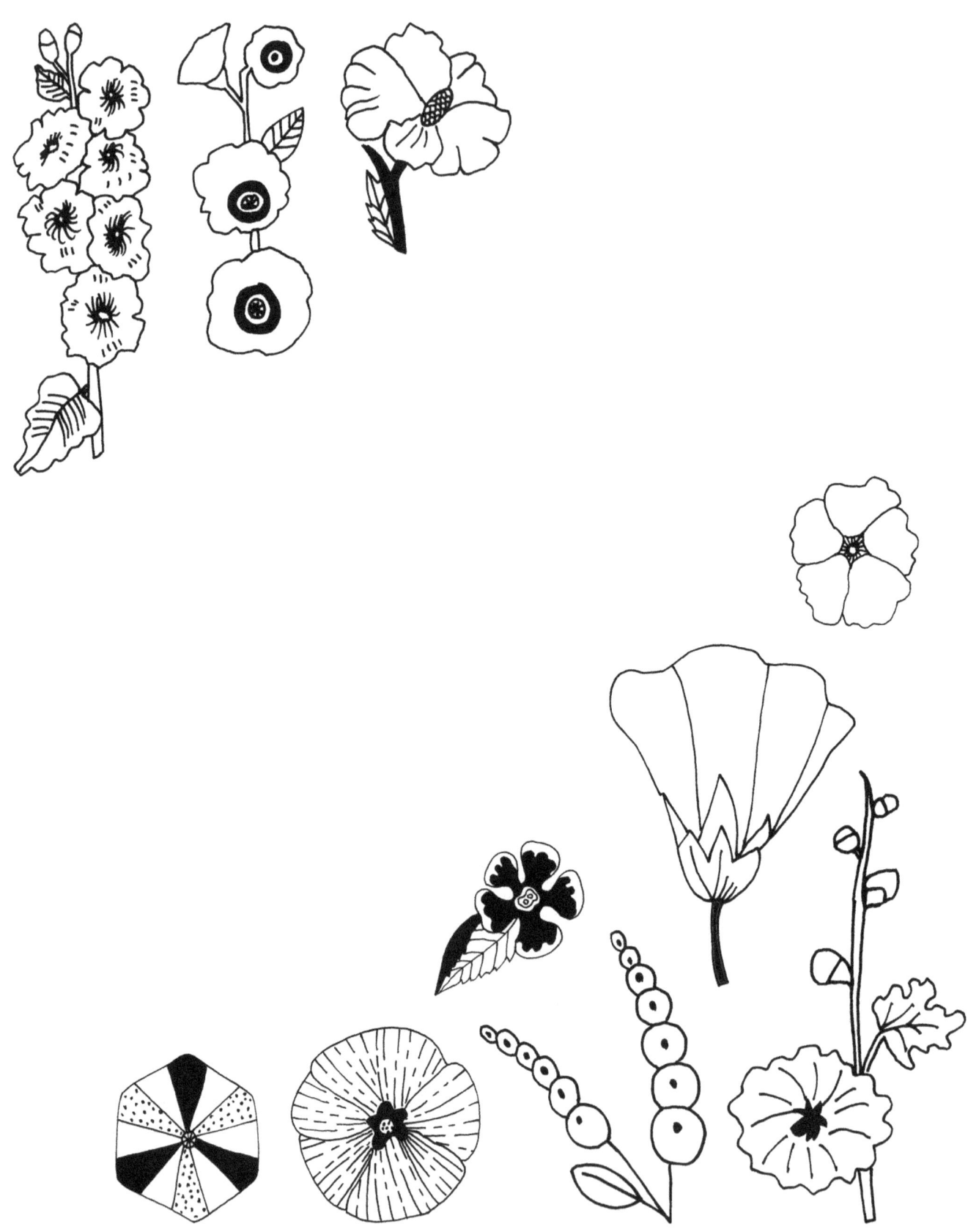

DRAW 20
Hollyhocks

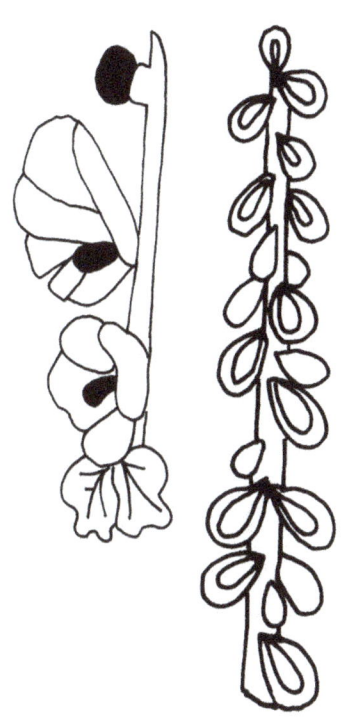

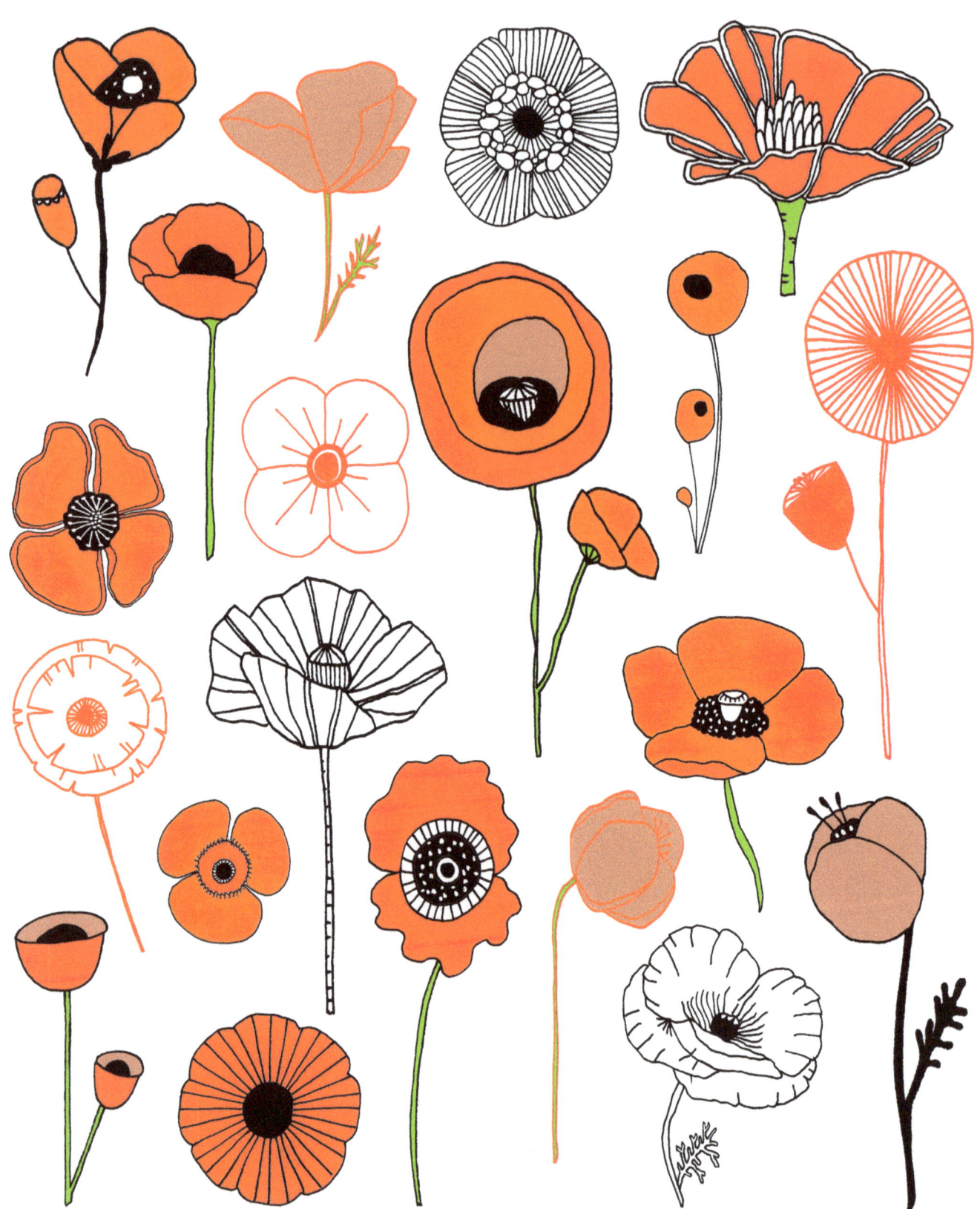

DRAW 20
Poppies

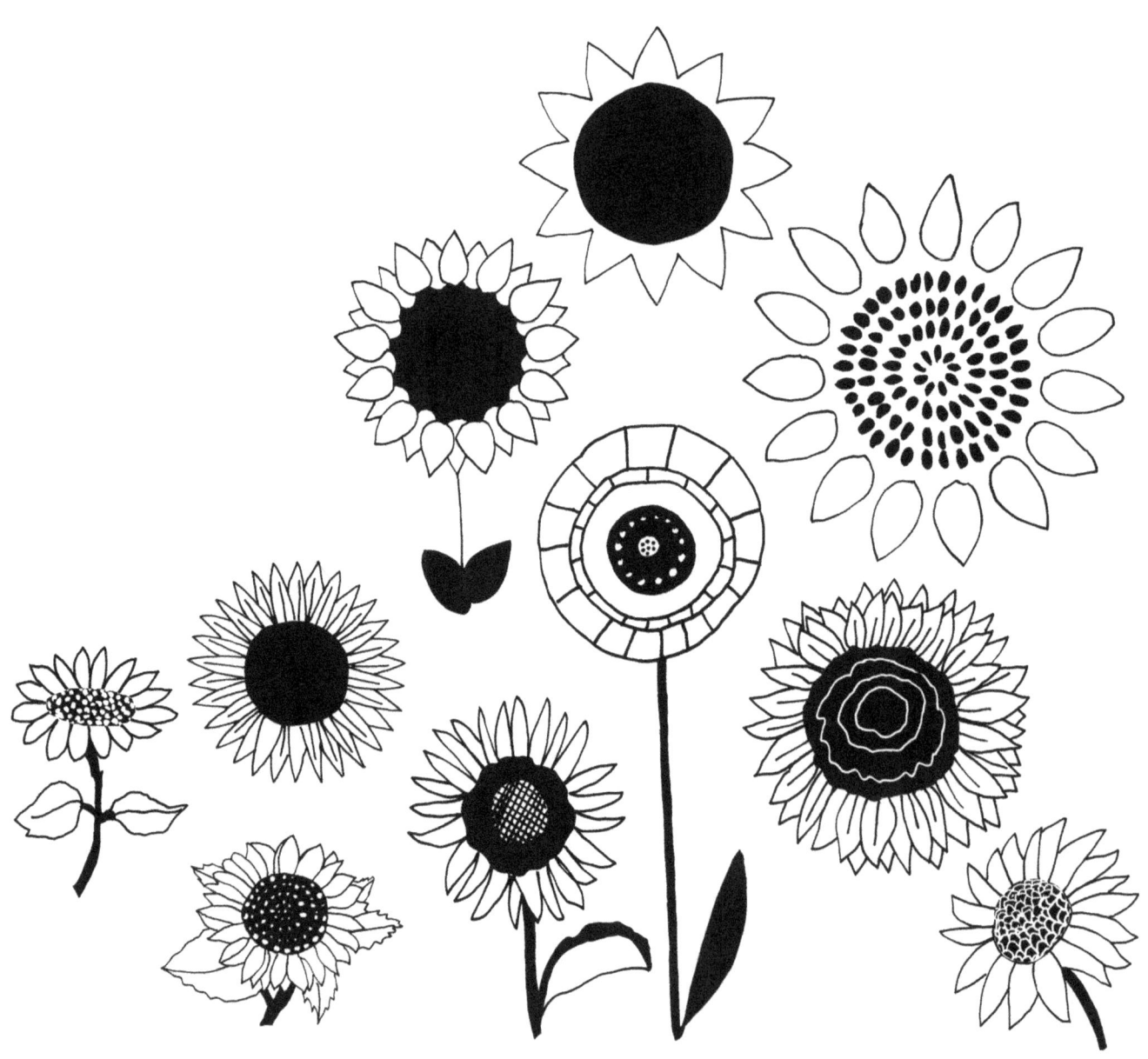

DRAW 20
Sunflowers

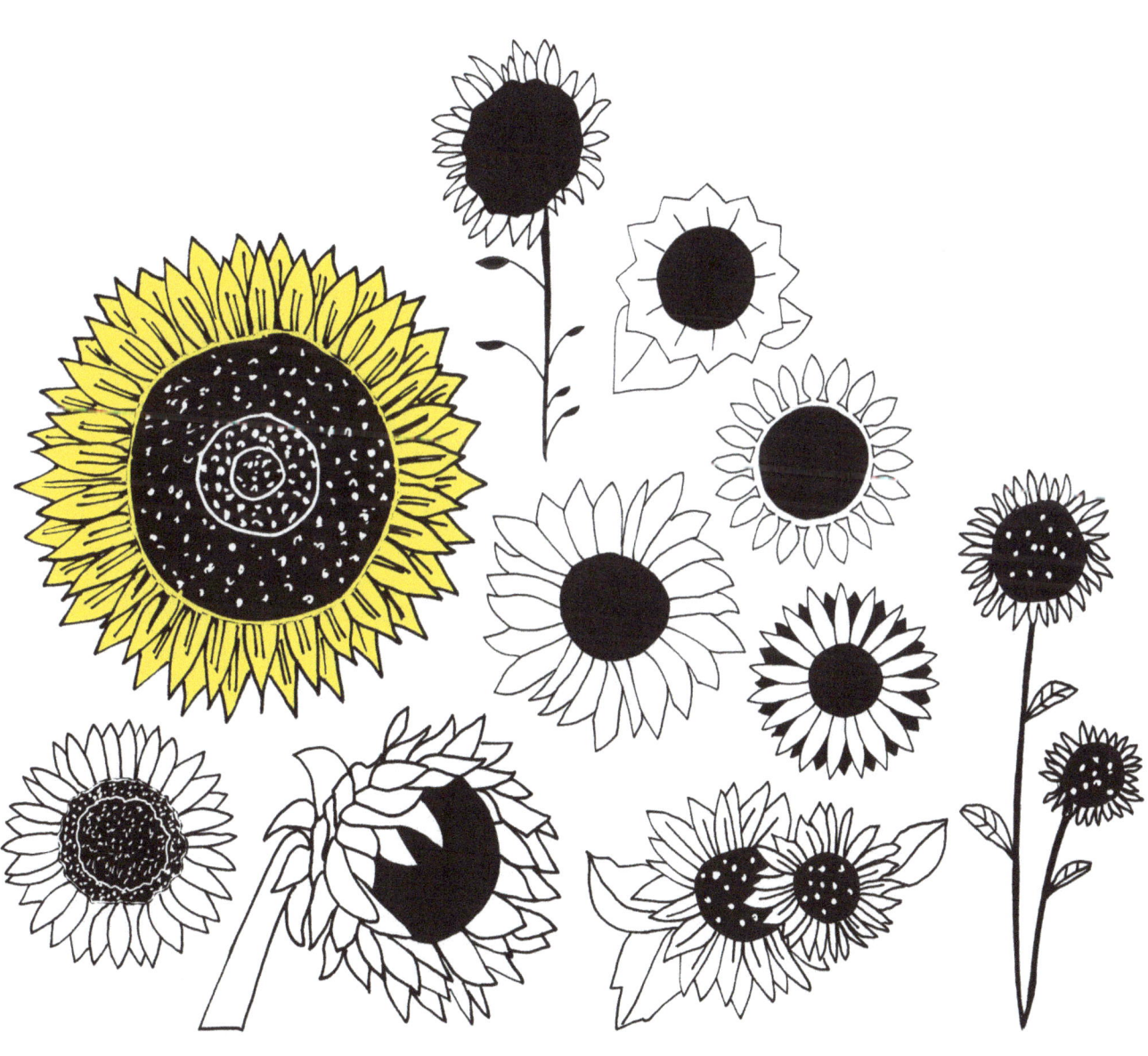

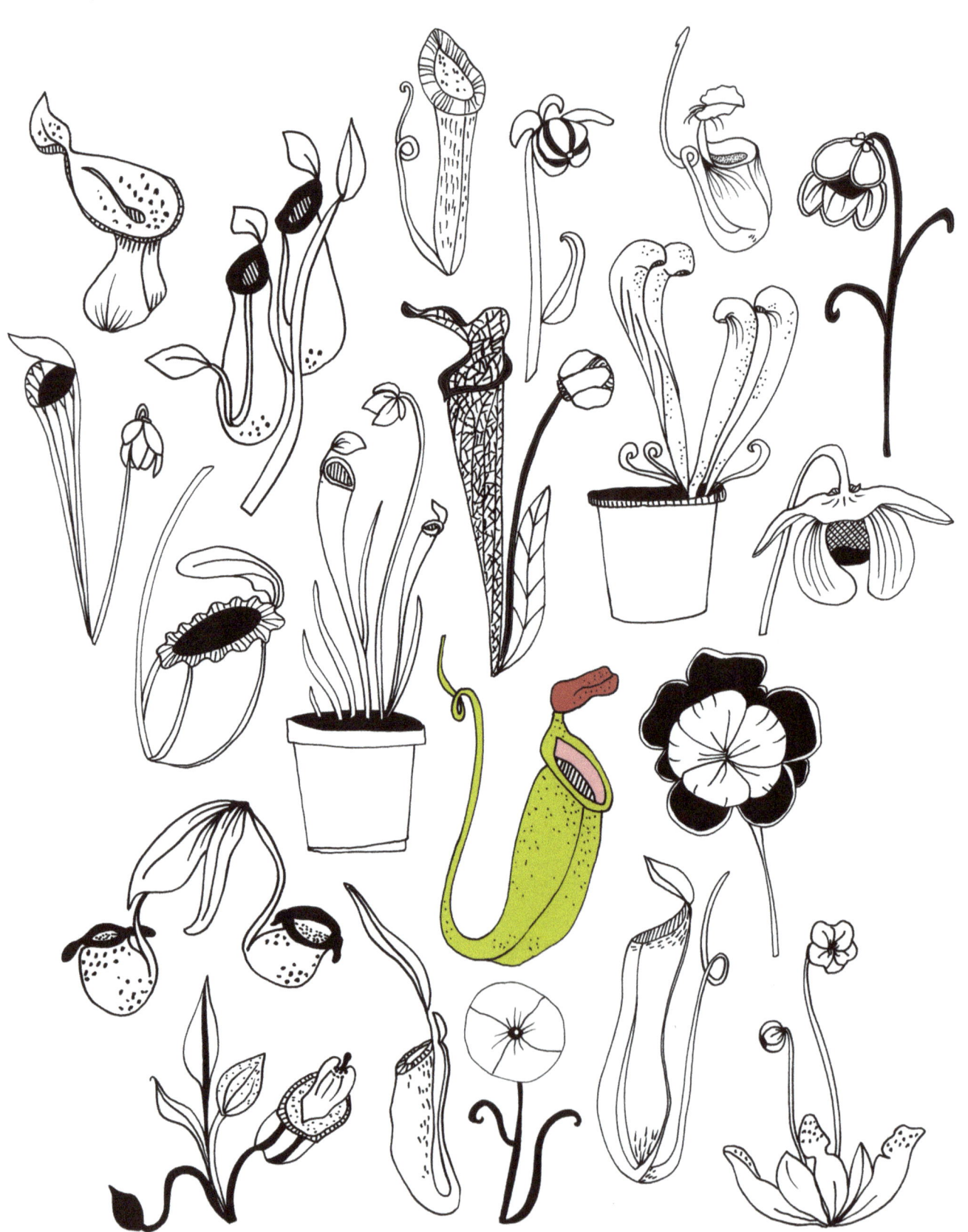

DRAW 20
PITCHER PLANTS

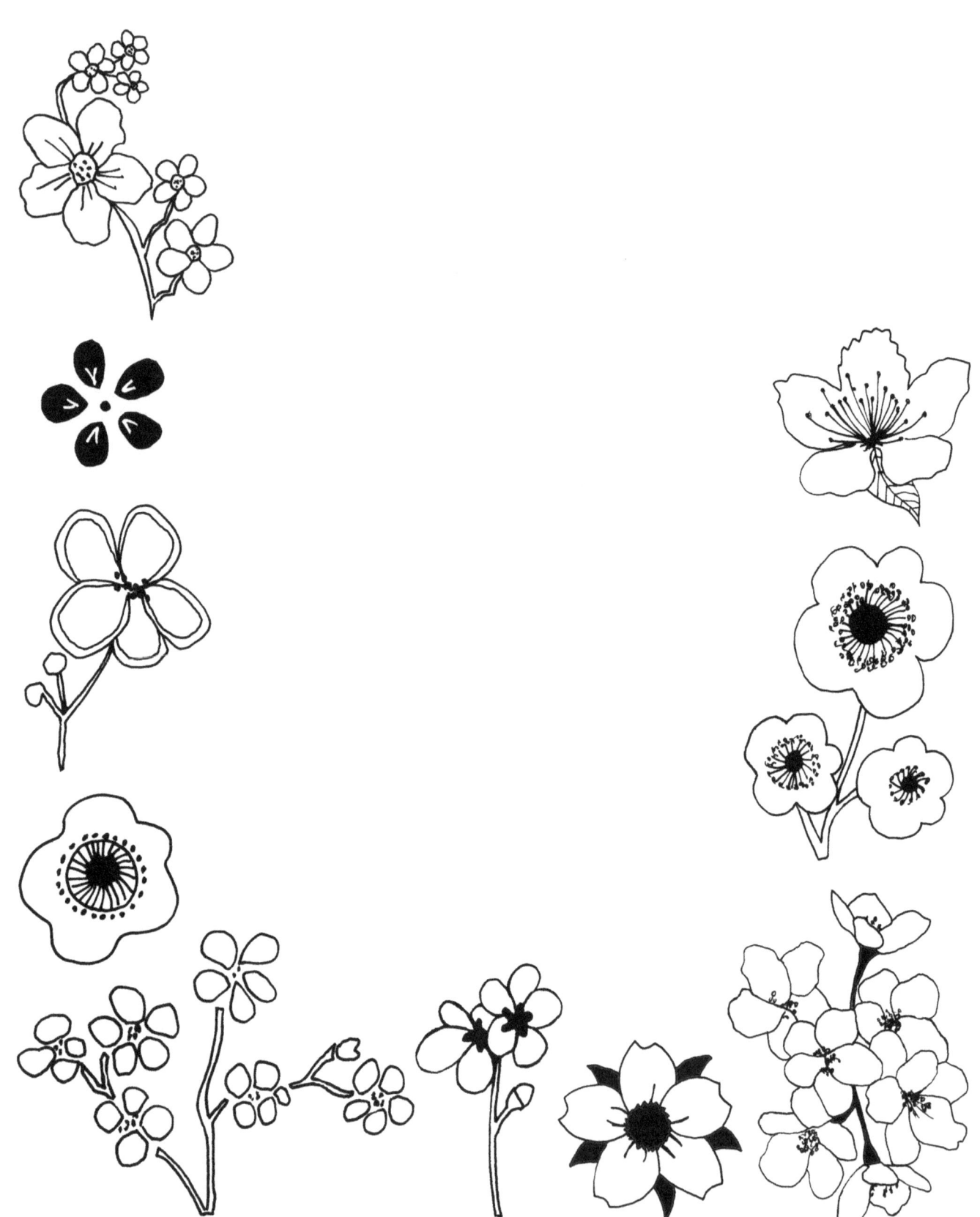

DRAW 20
Cherry Blossoms

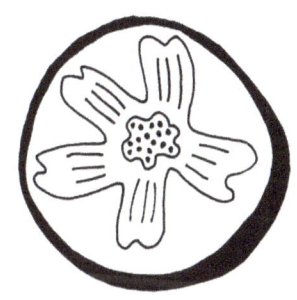

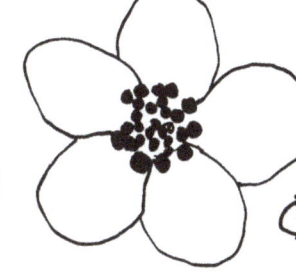

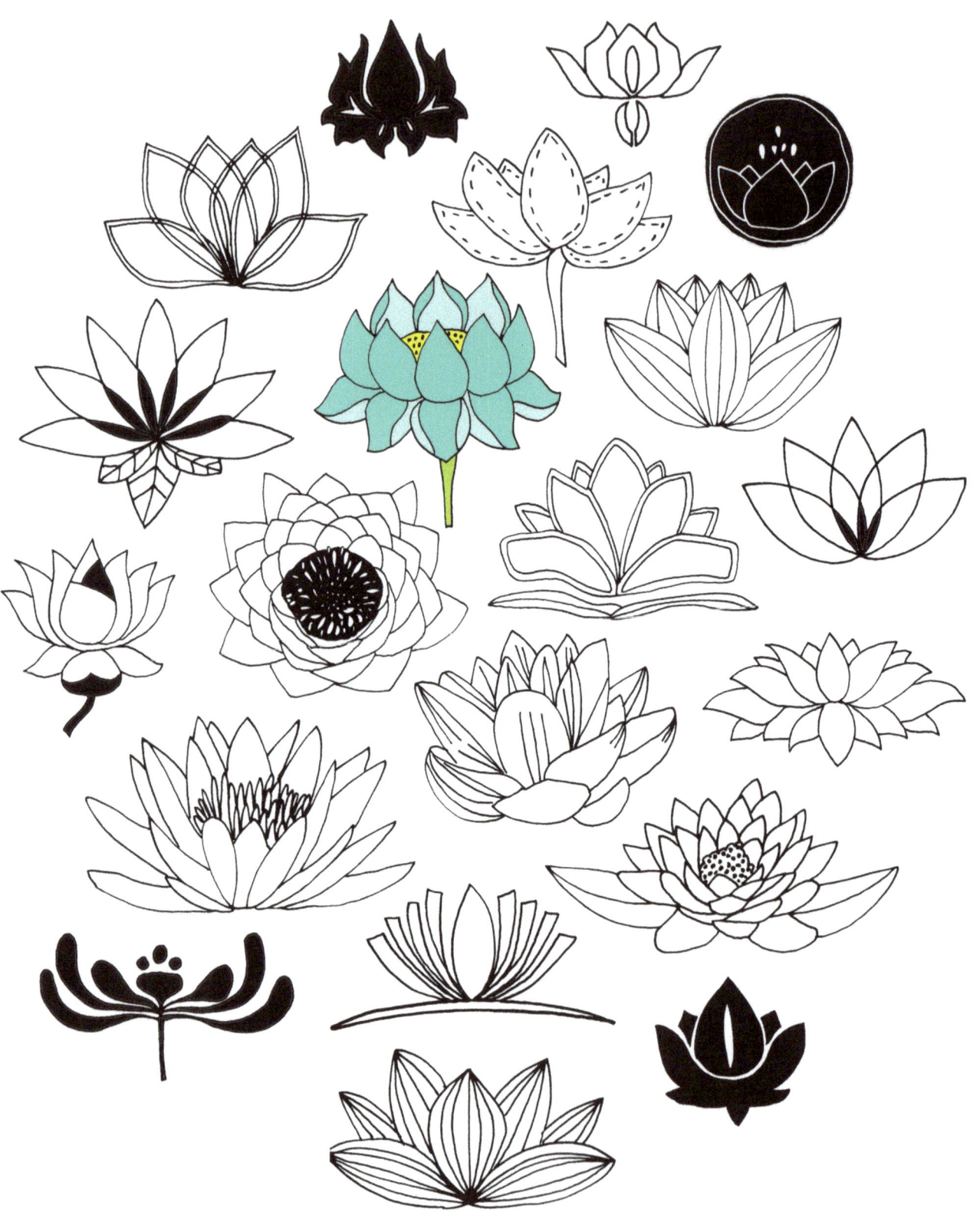

DRAW 20
Lotus Flowers

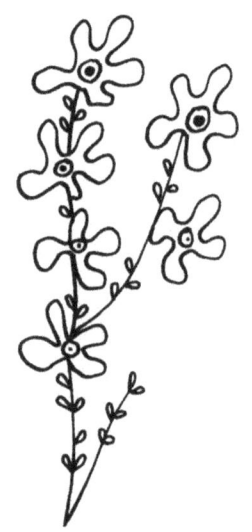
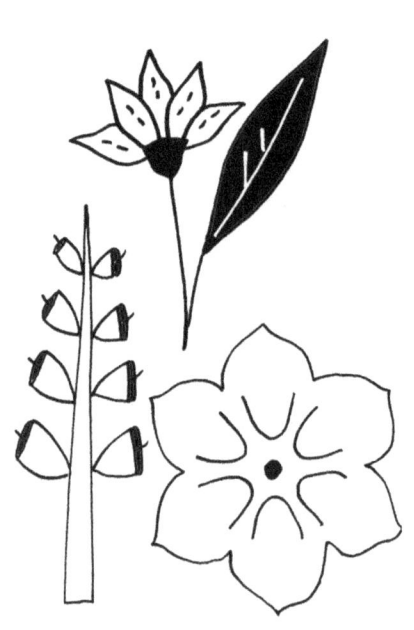
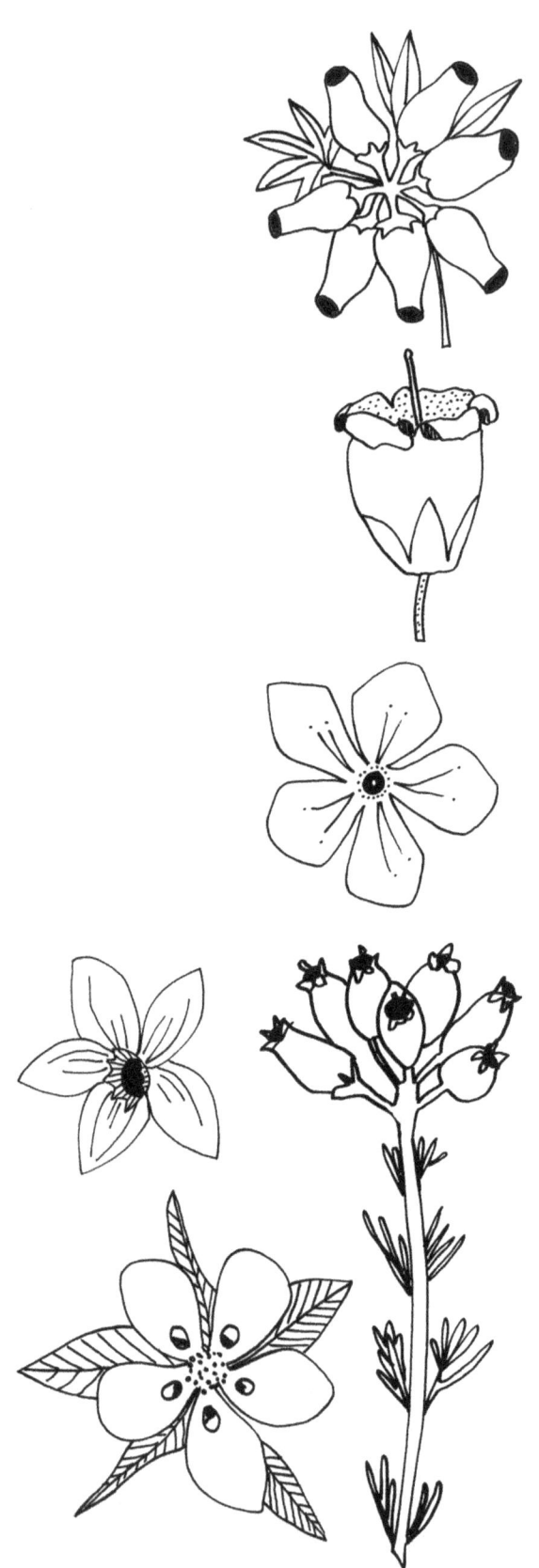

DRAW 20
Heather

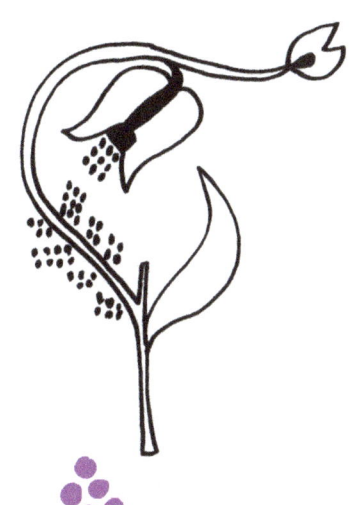
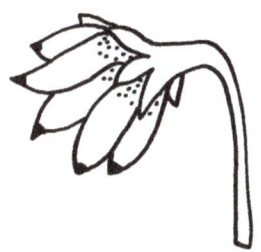

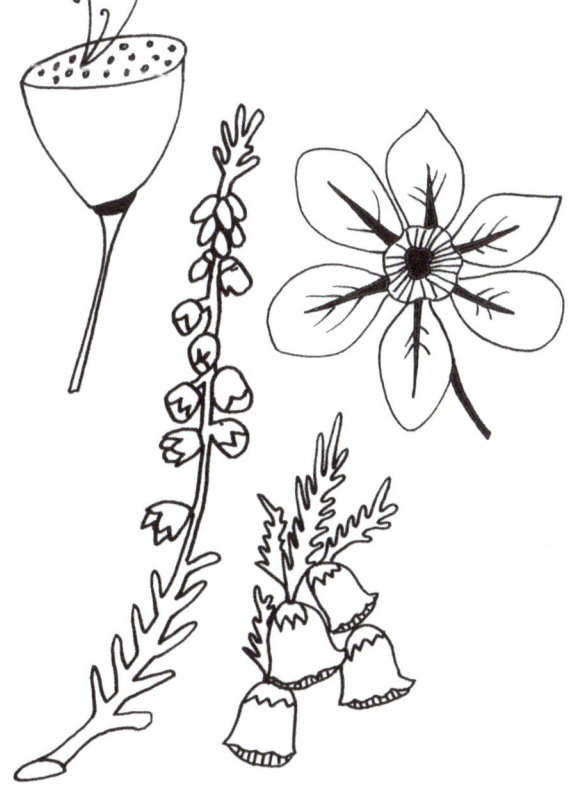
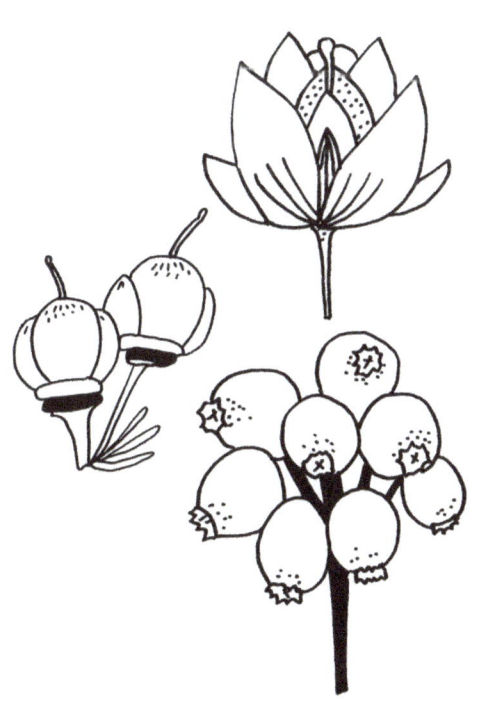

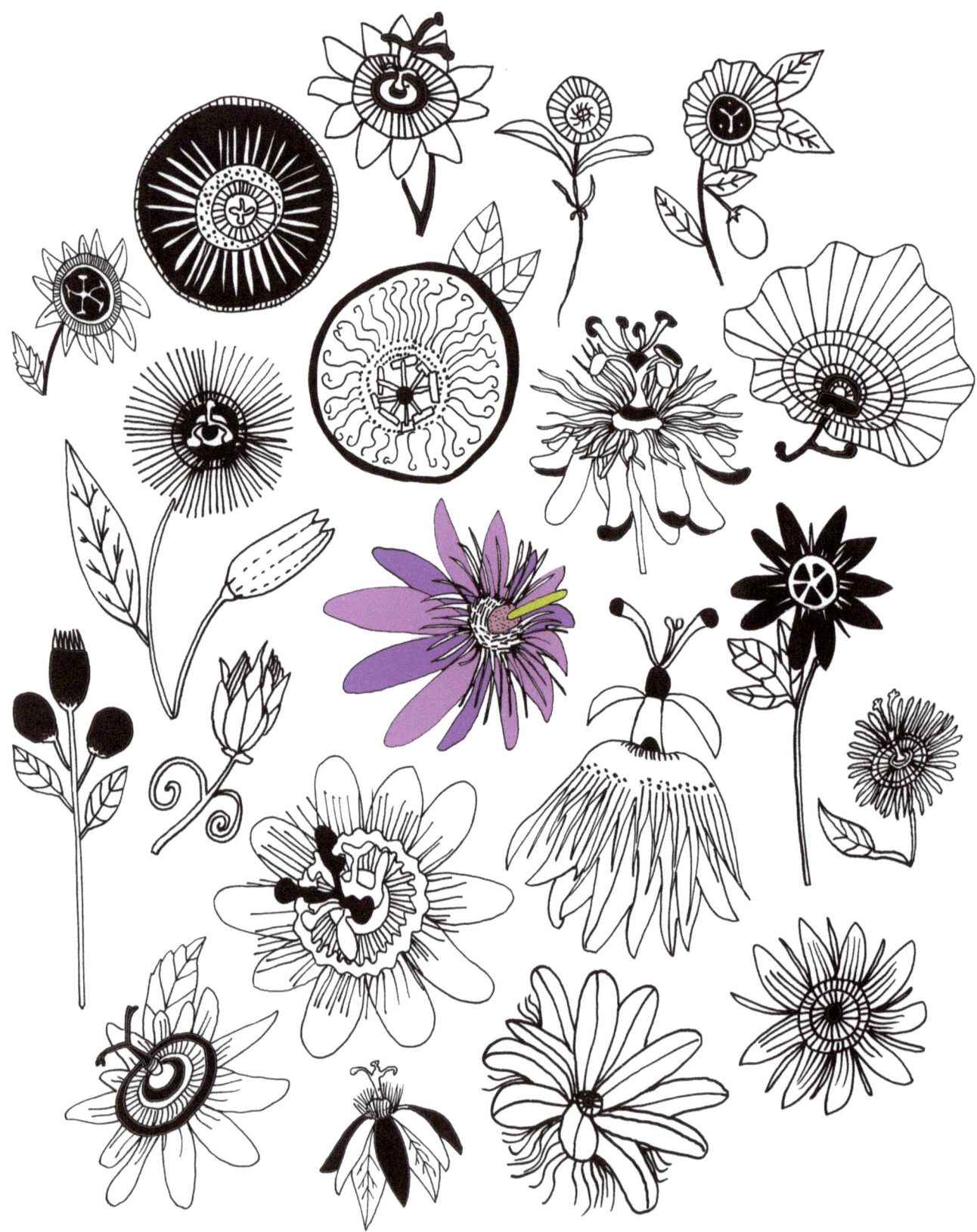

… DRAW 20
Maypops

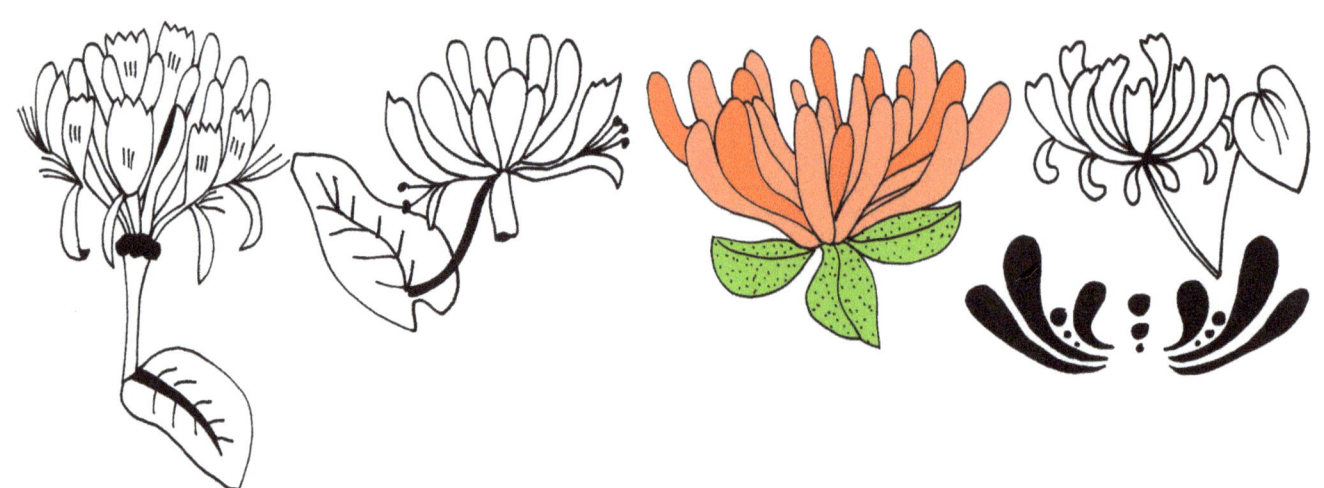
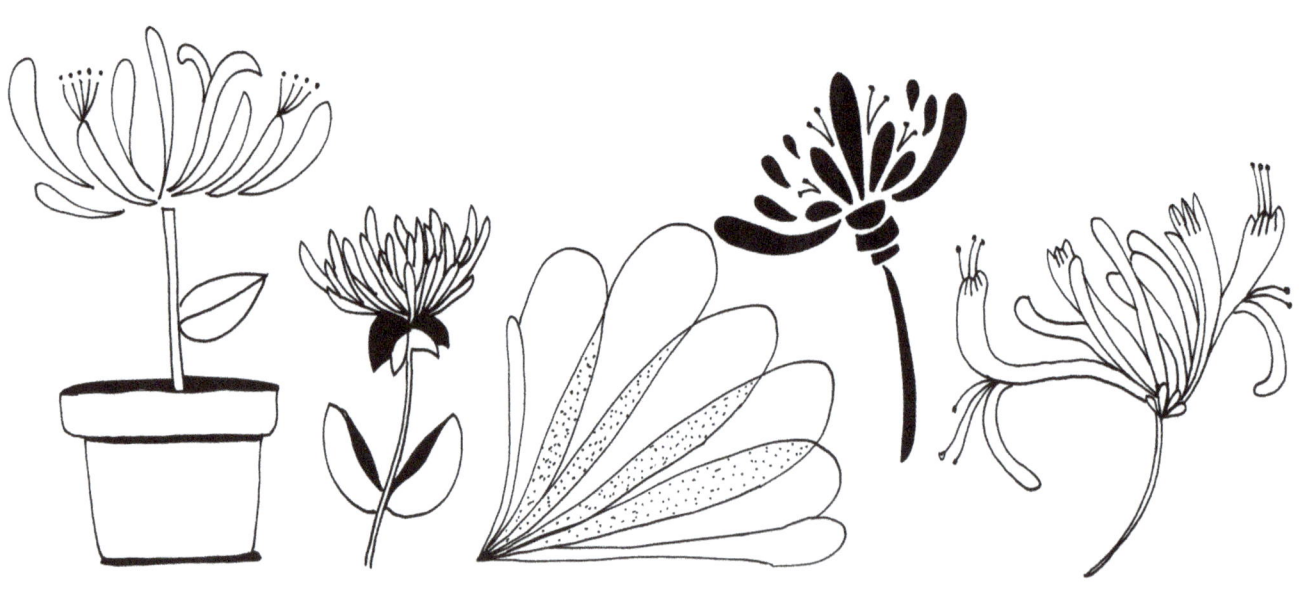

DRAW 20
Honeysuckle

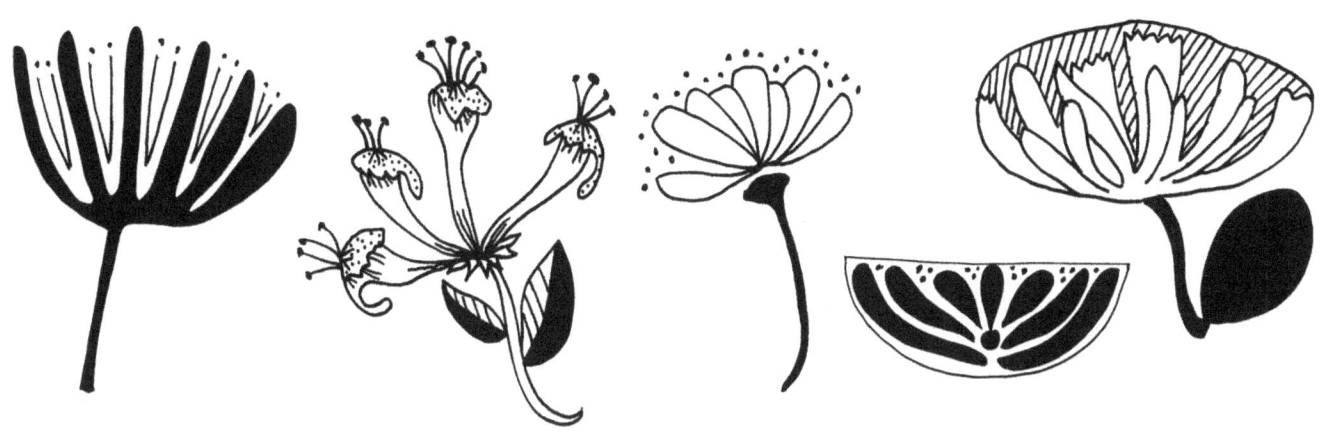

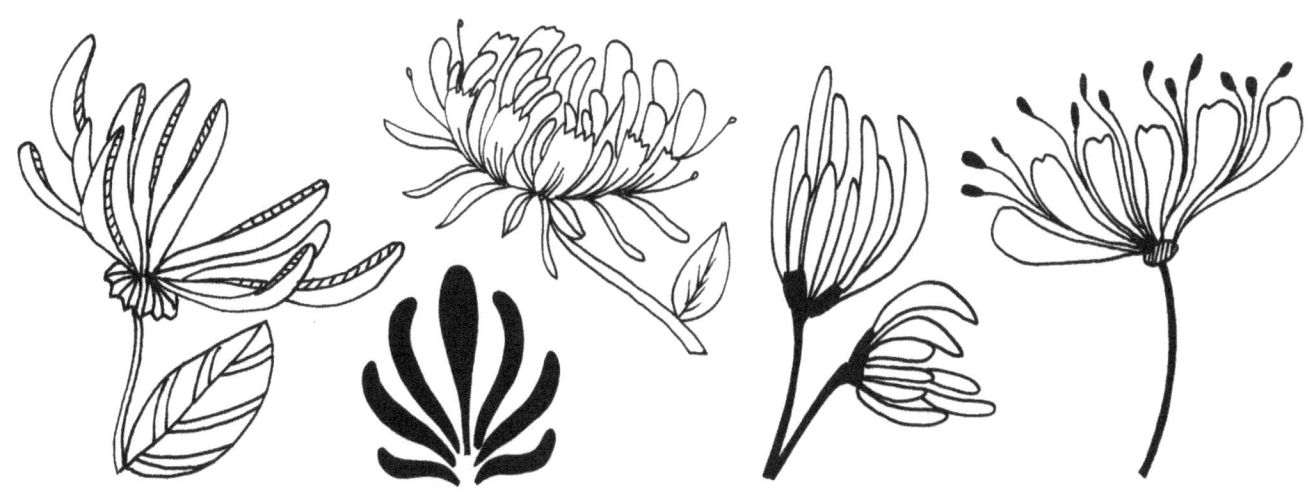

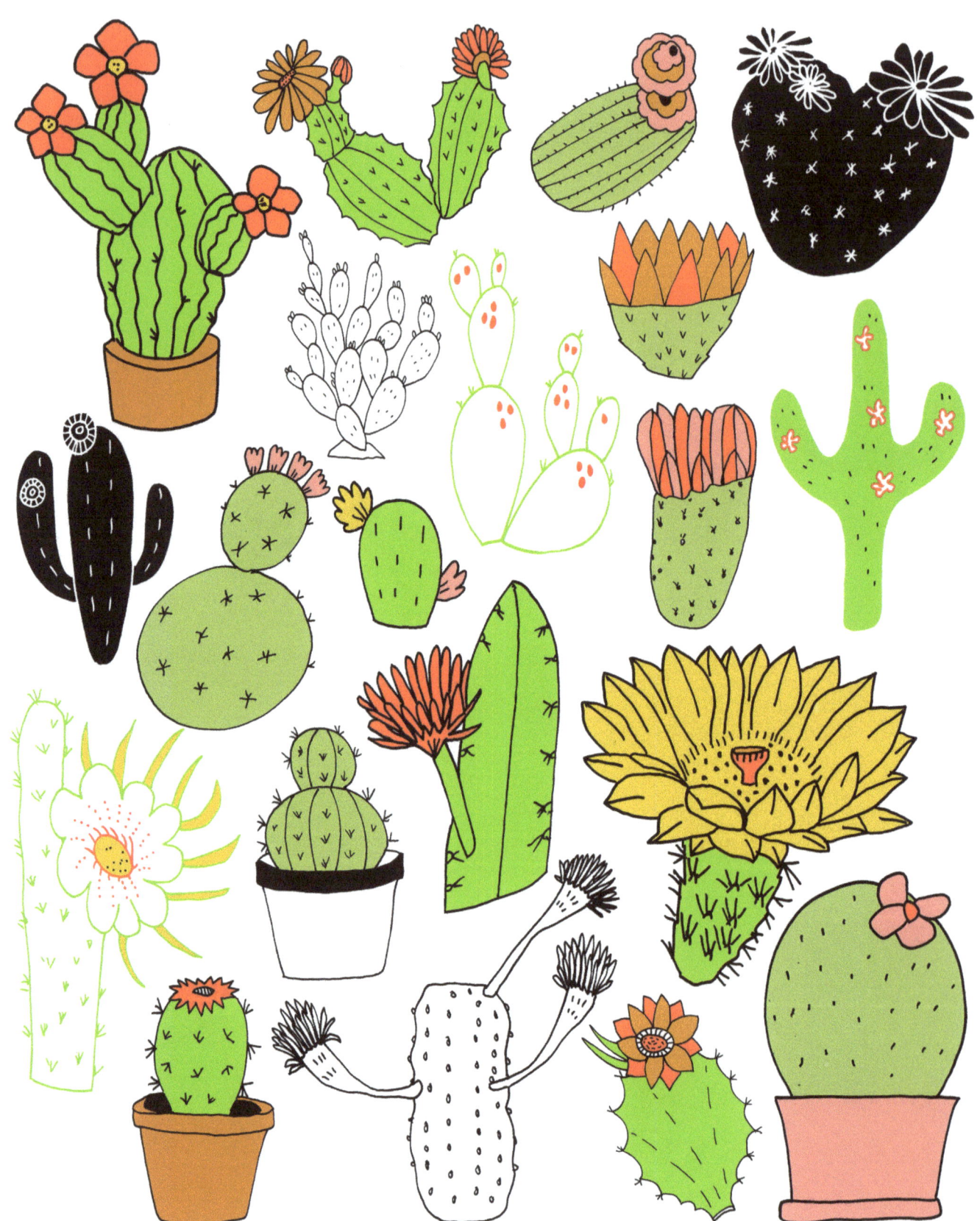

DRAW 20
CACTUS FLOWERS

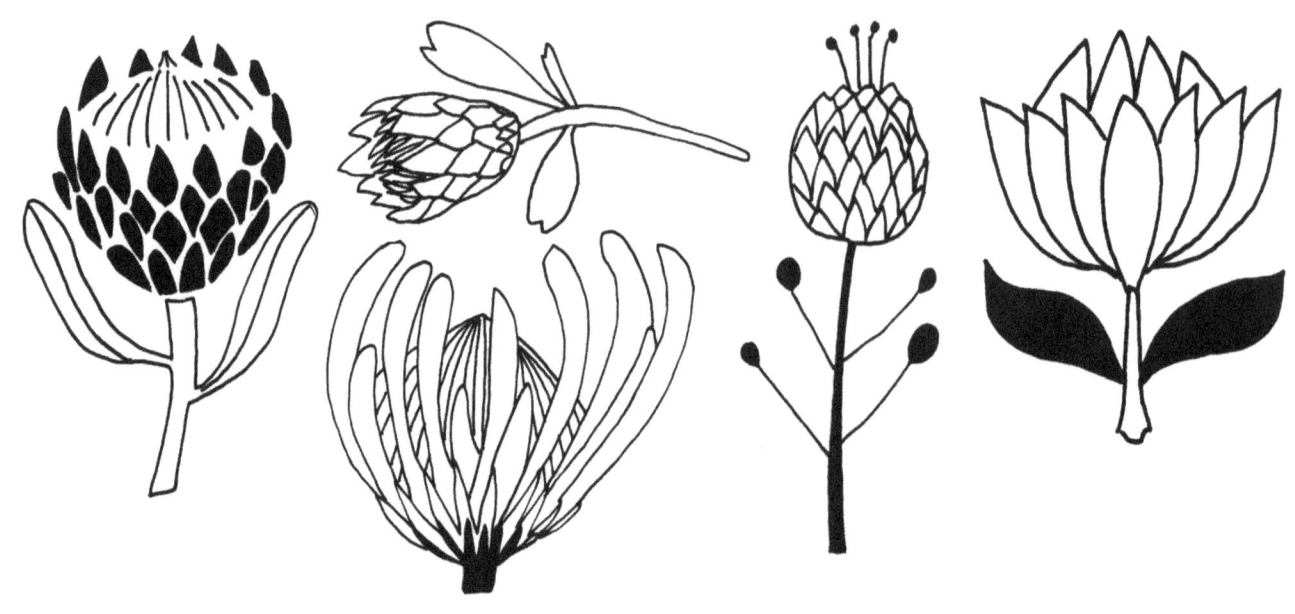
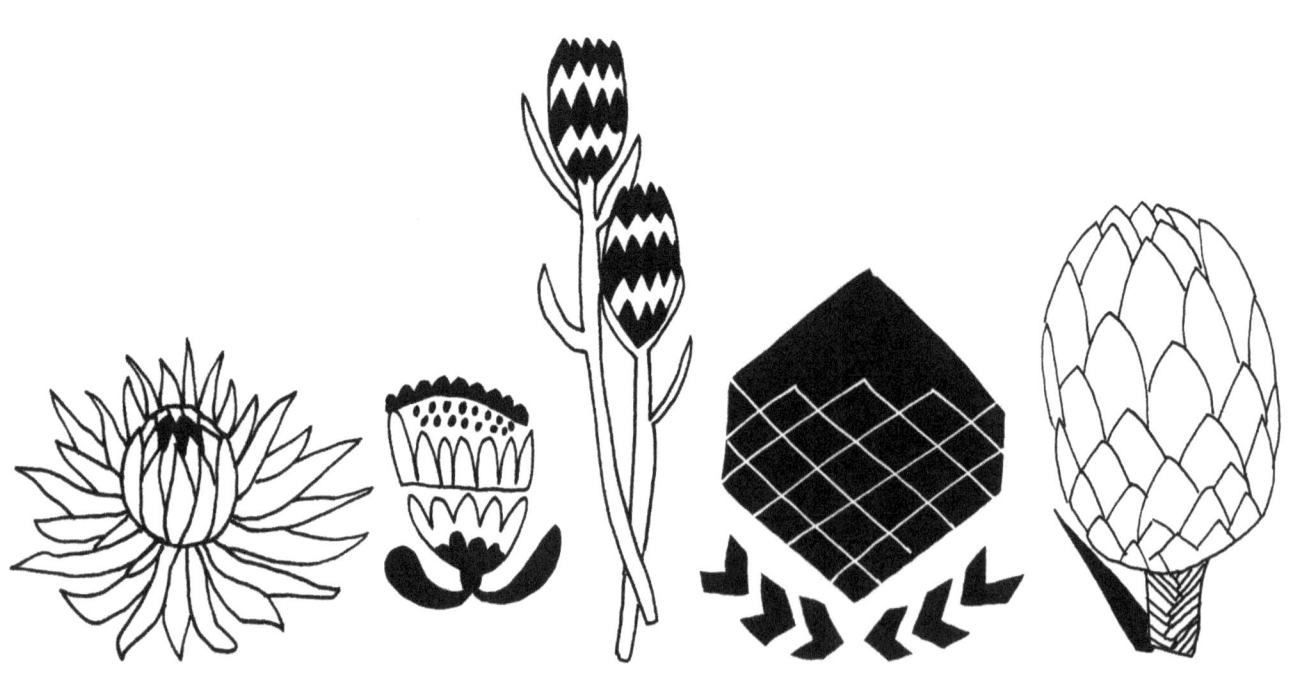

DRAW 20
Protea

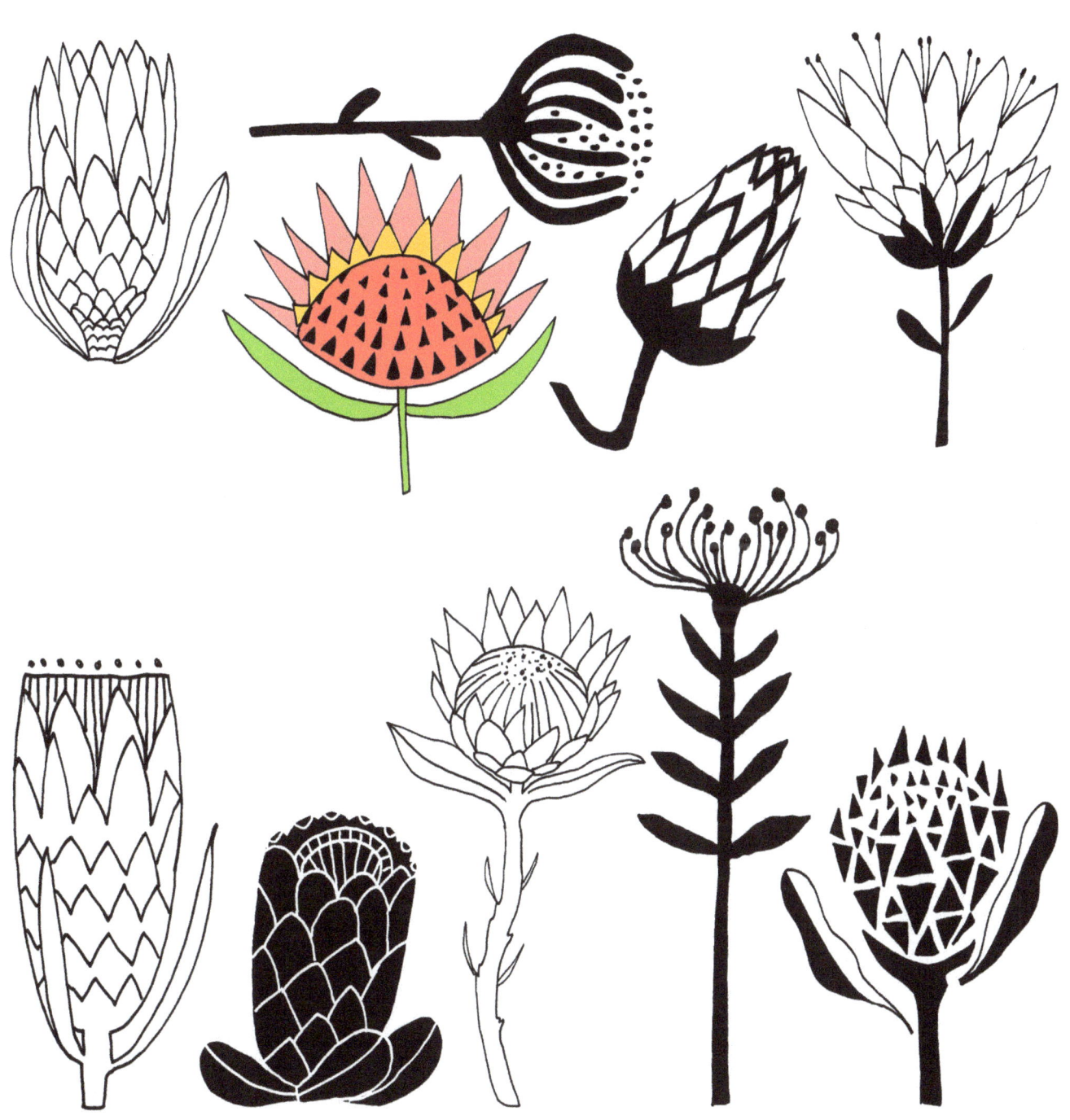

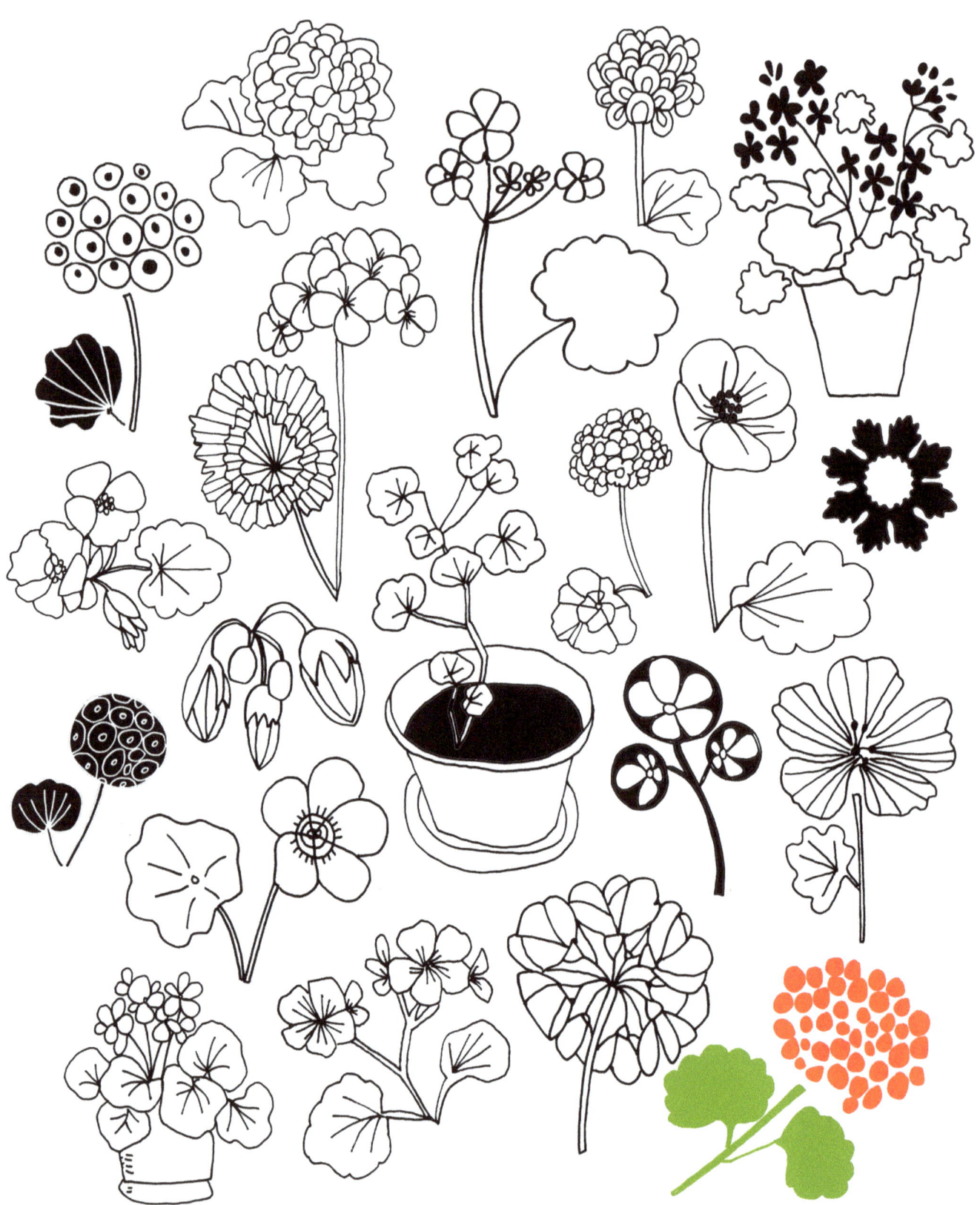

DRAW 20
Geraniums

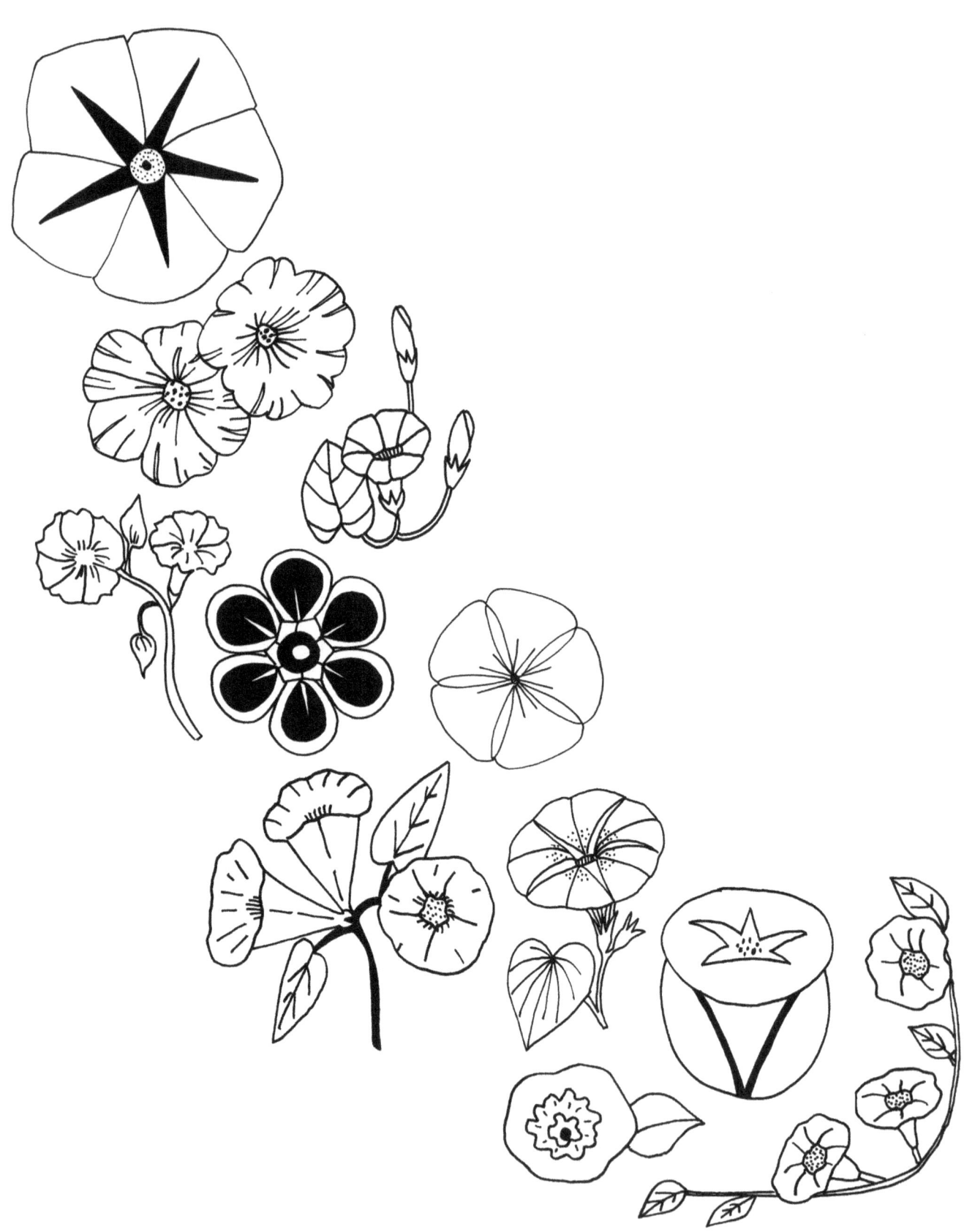

DRAW 20
Morning Glories

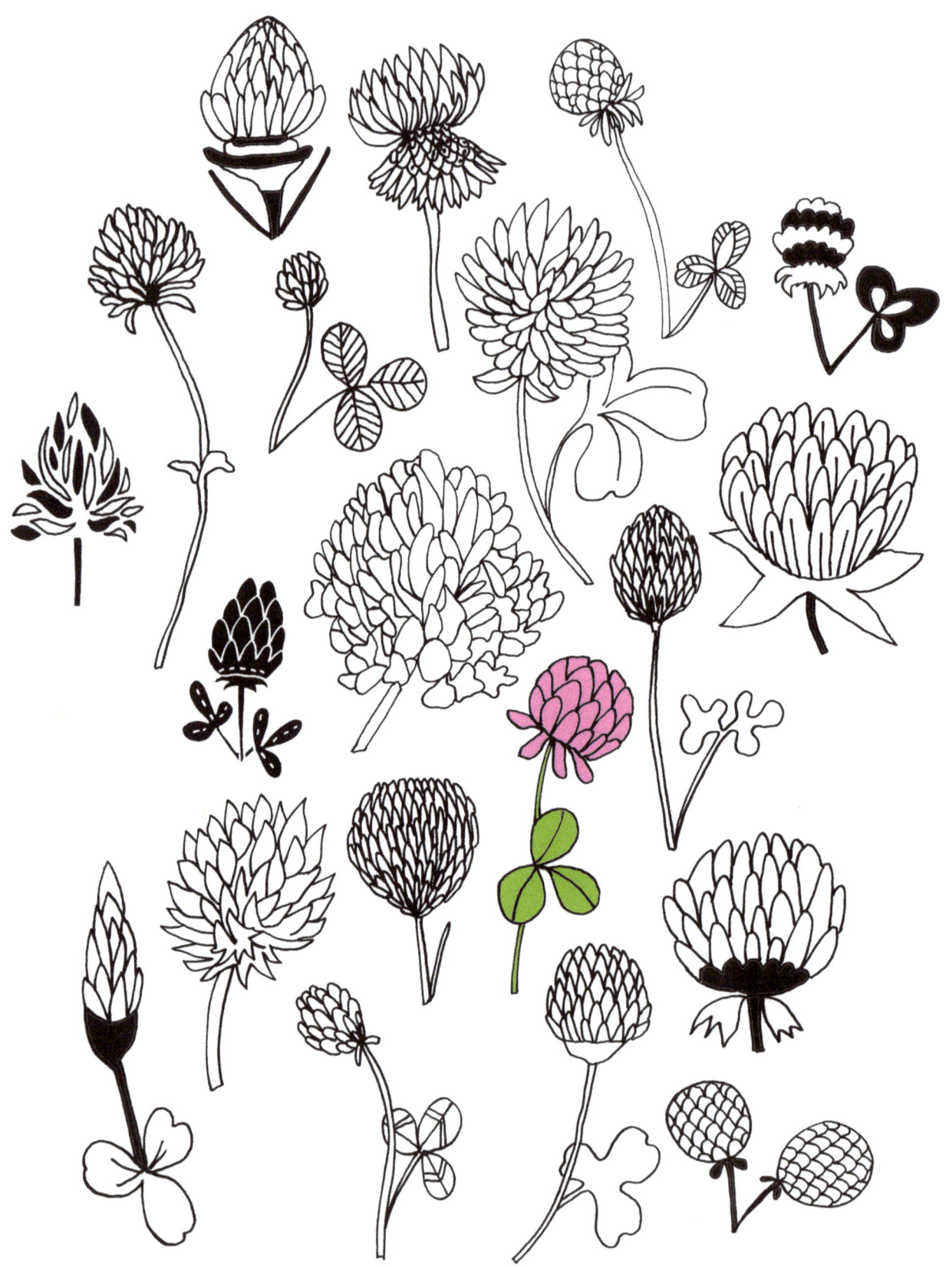

DRAW 20
Clovers

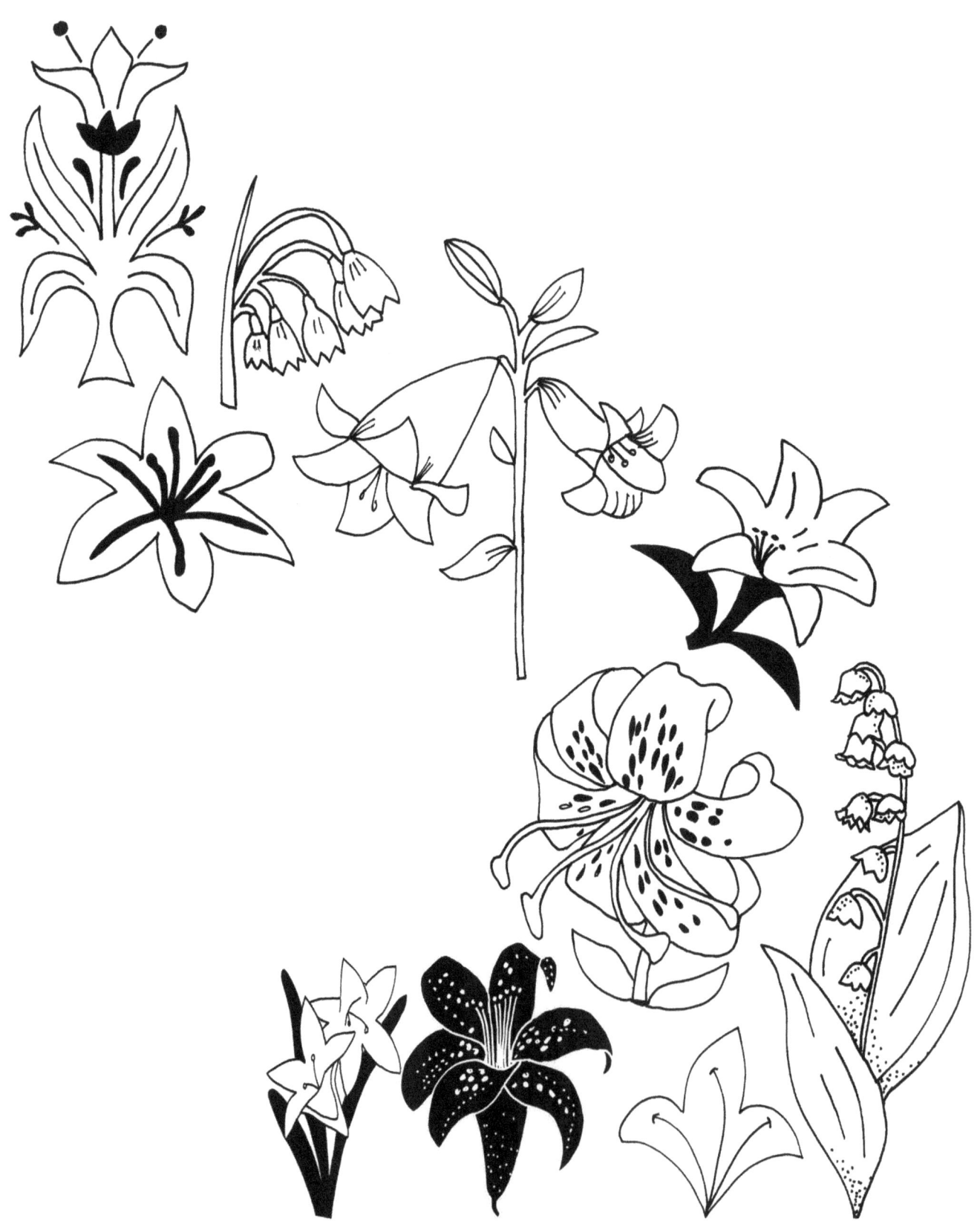

DRAW 20
Lillies

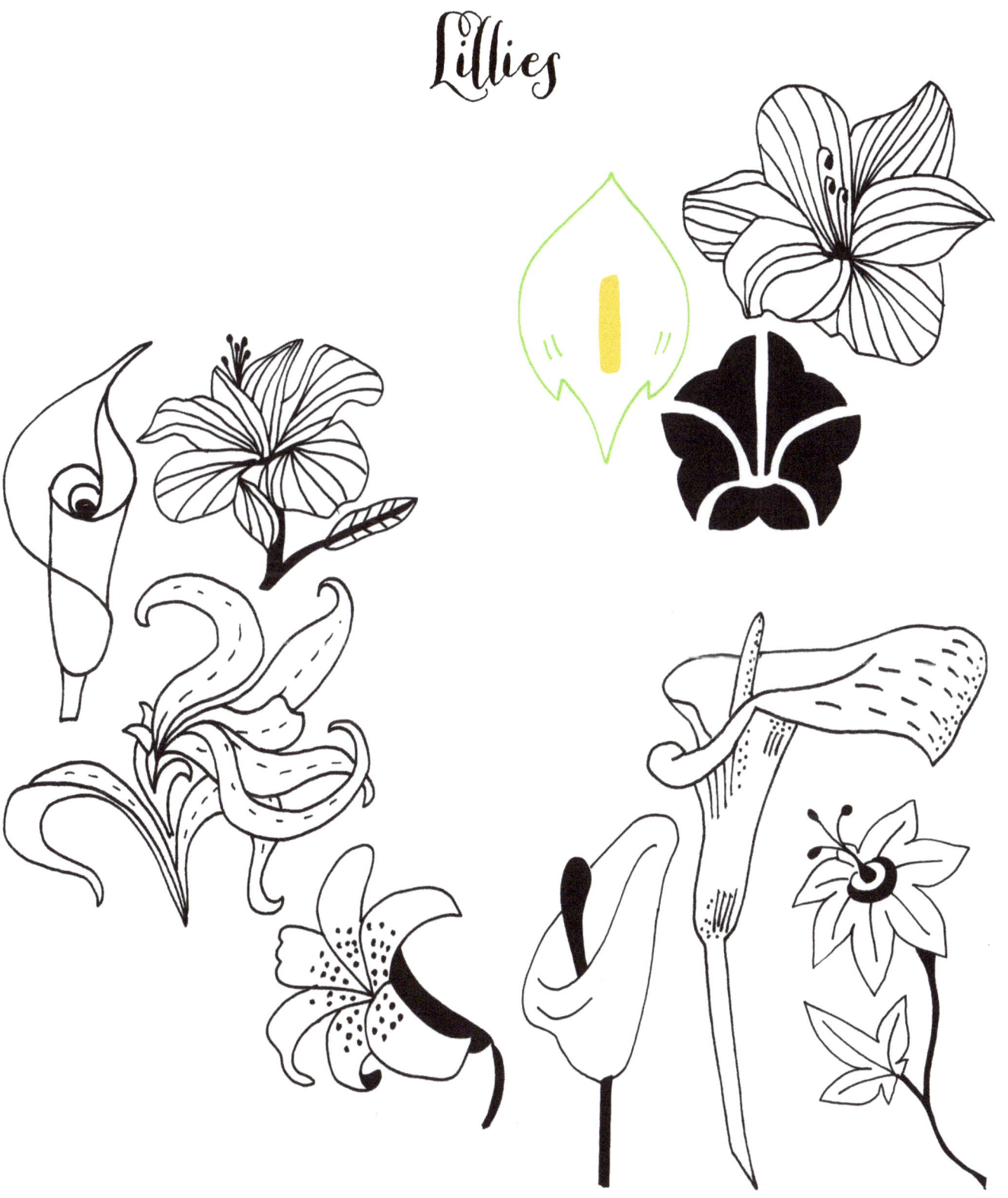

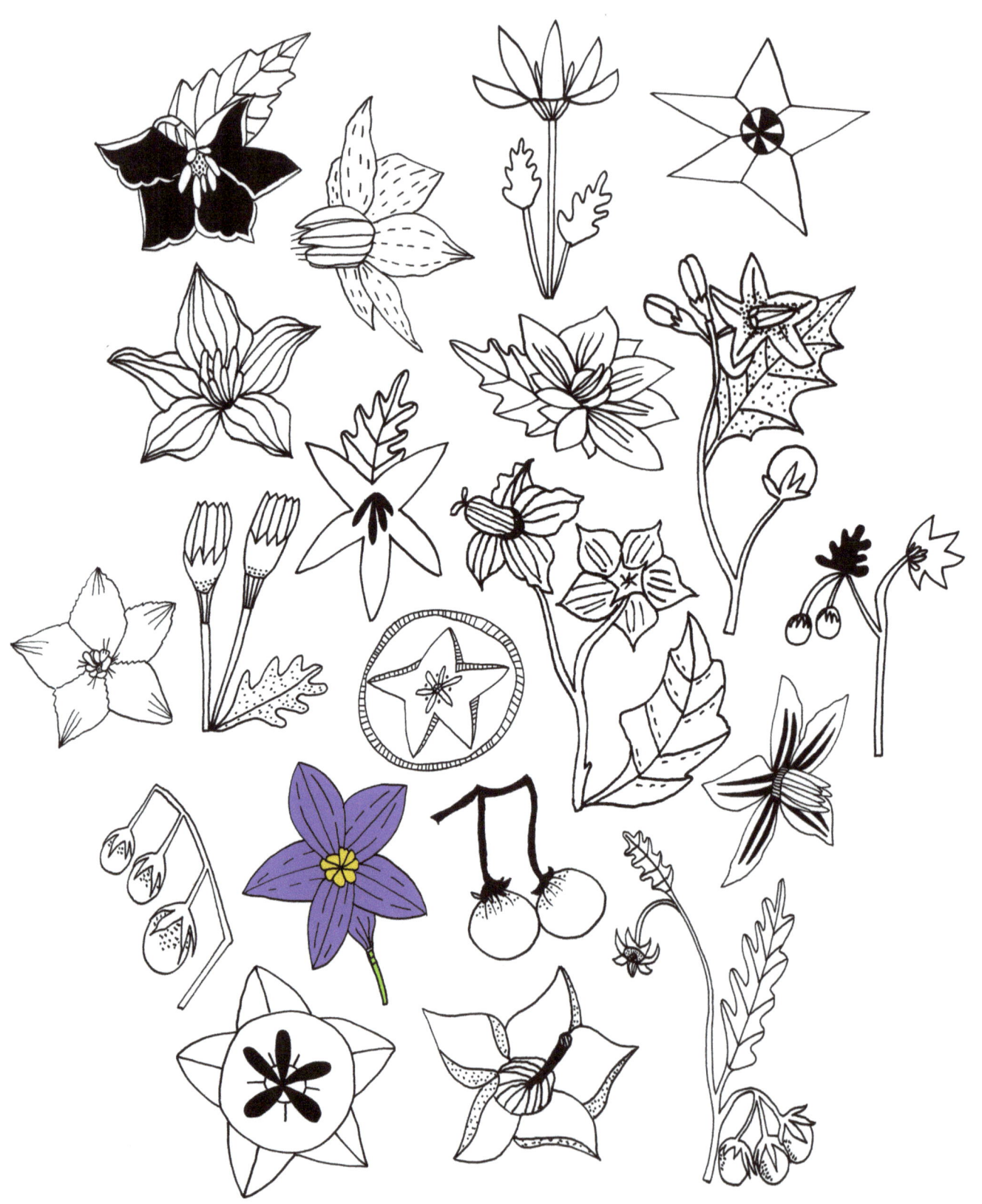

DRAW 20
Horse Nettle

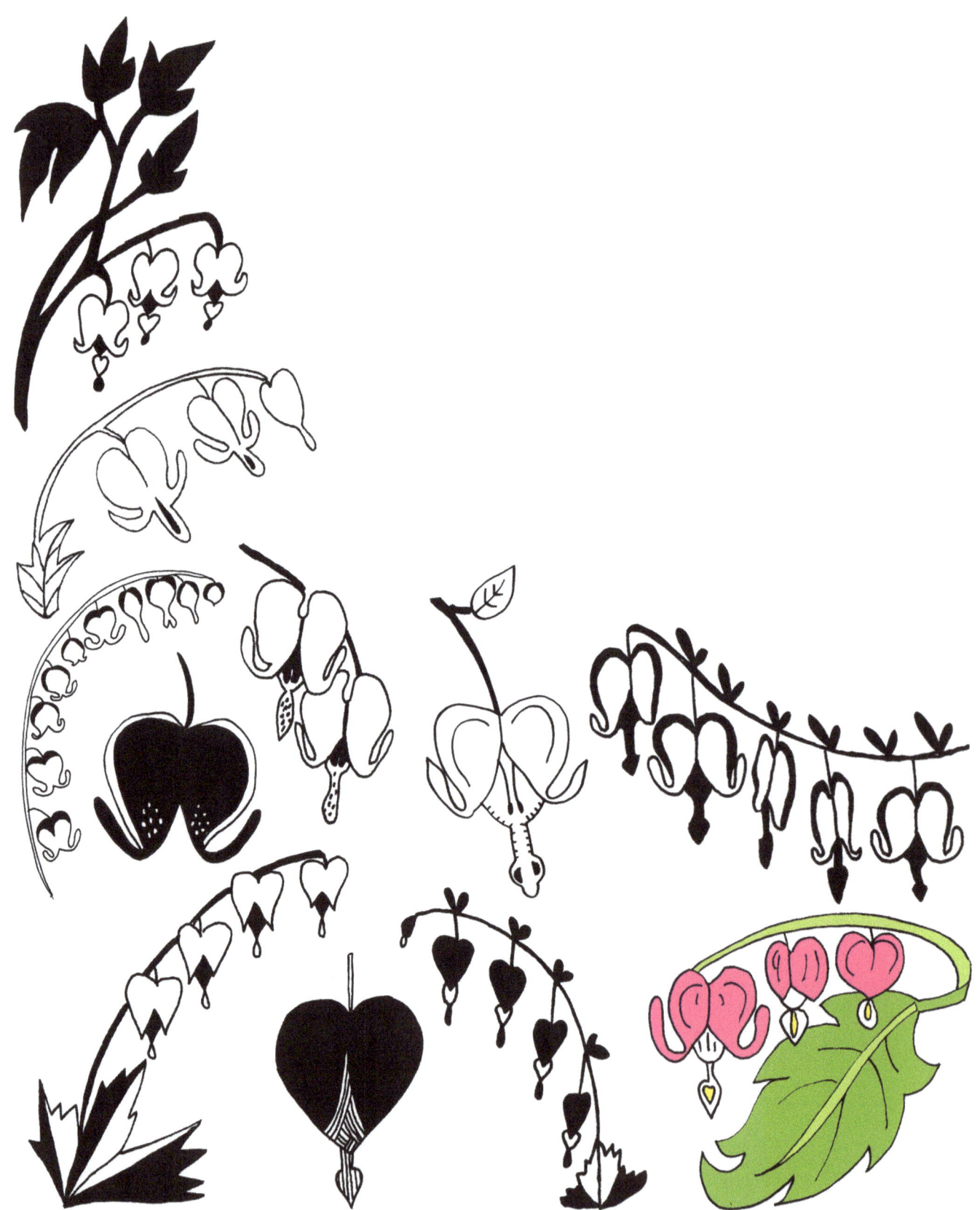

DRAW 20
Bleeding Hearts

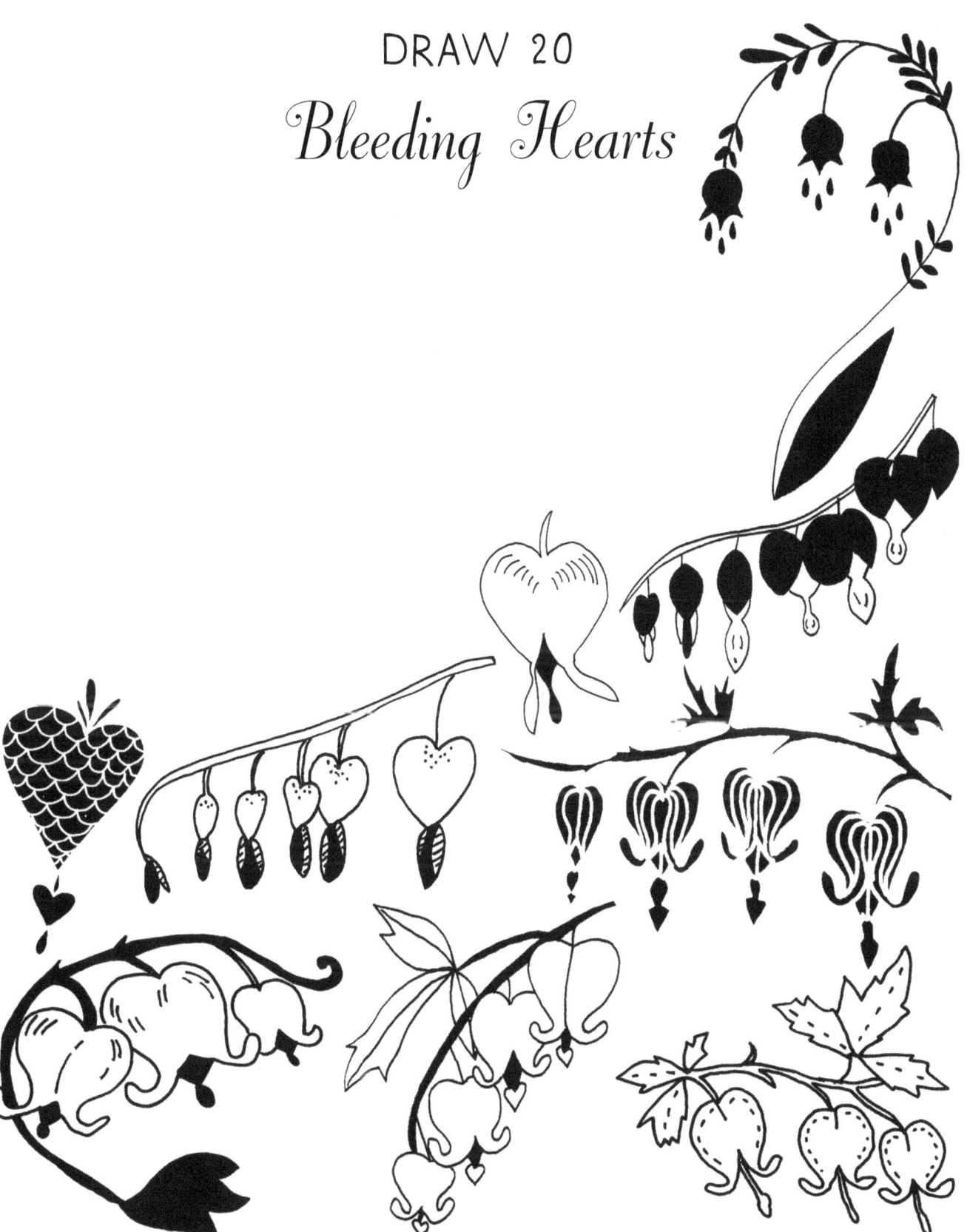

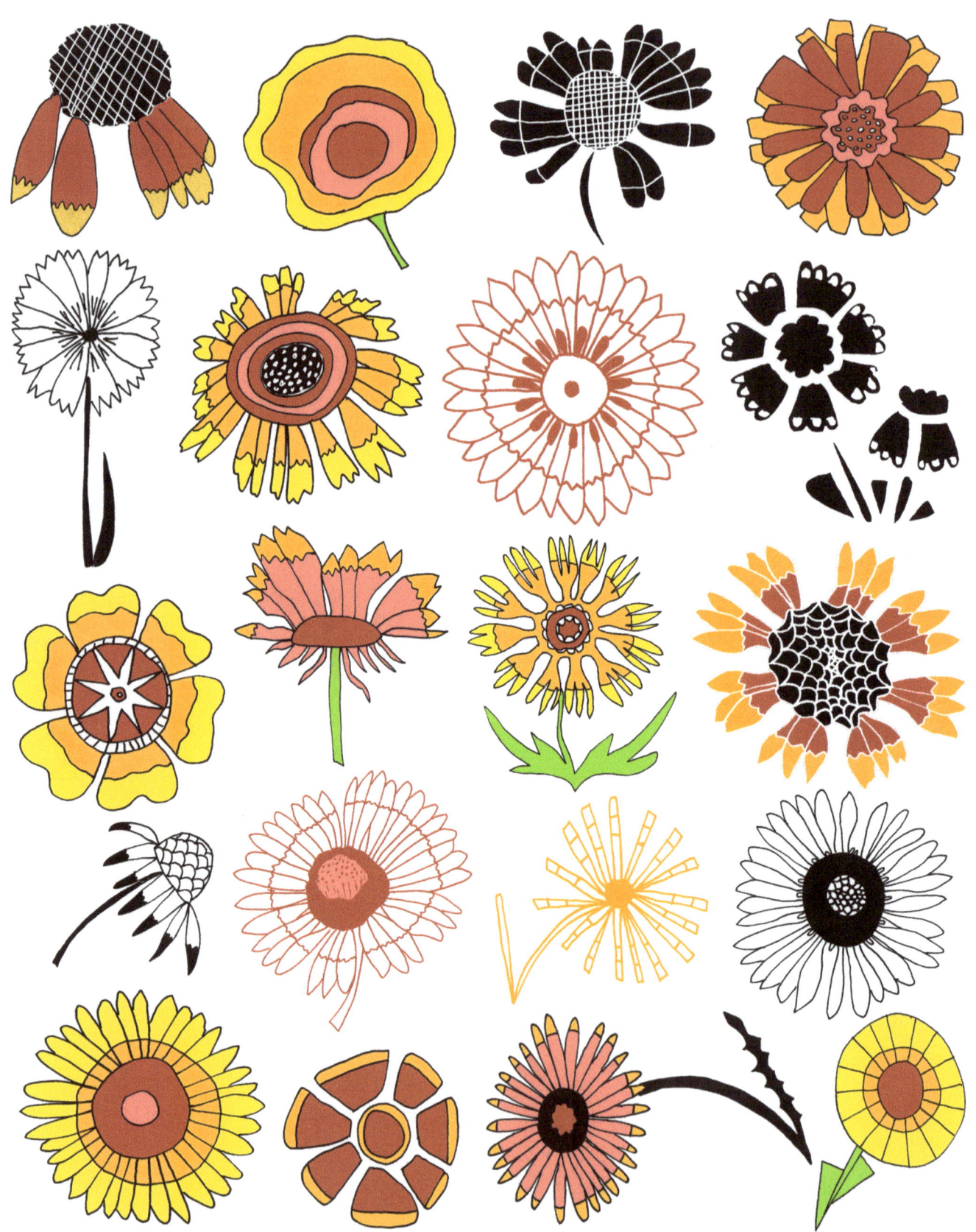

DRAW 20
Indian Blankets

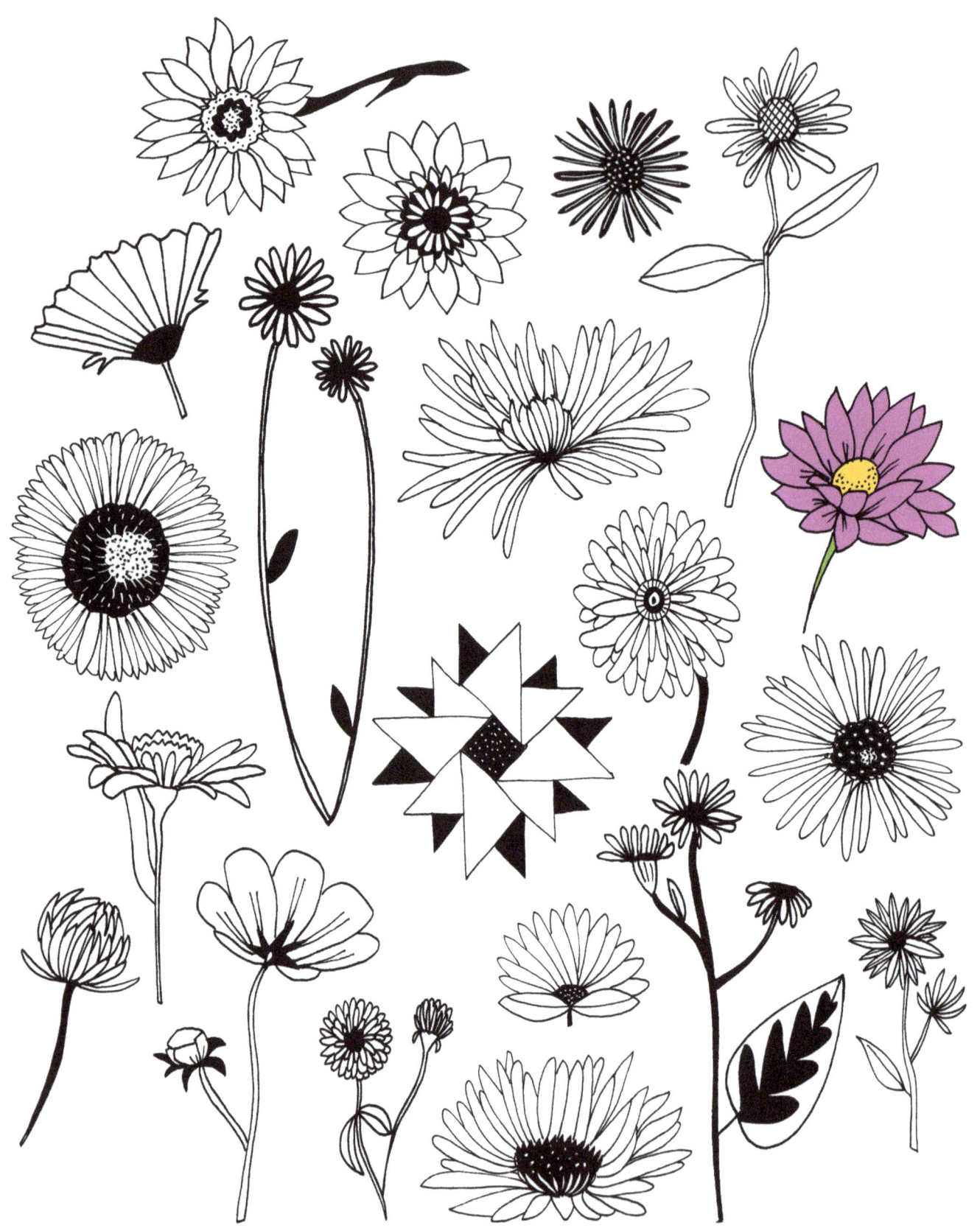

DRAW 20
ASTERS

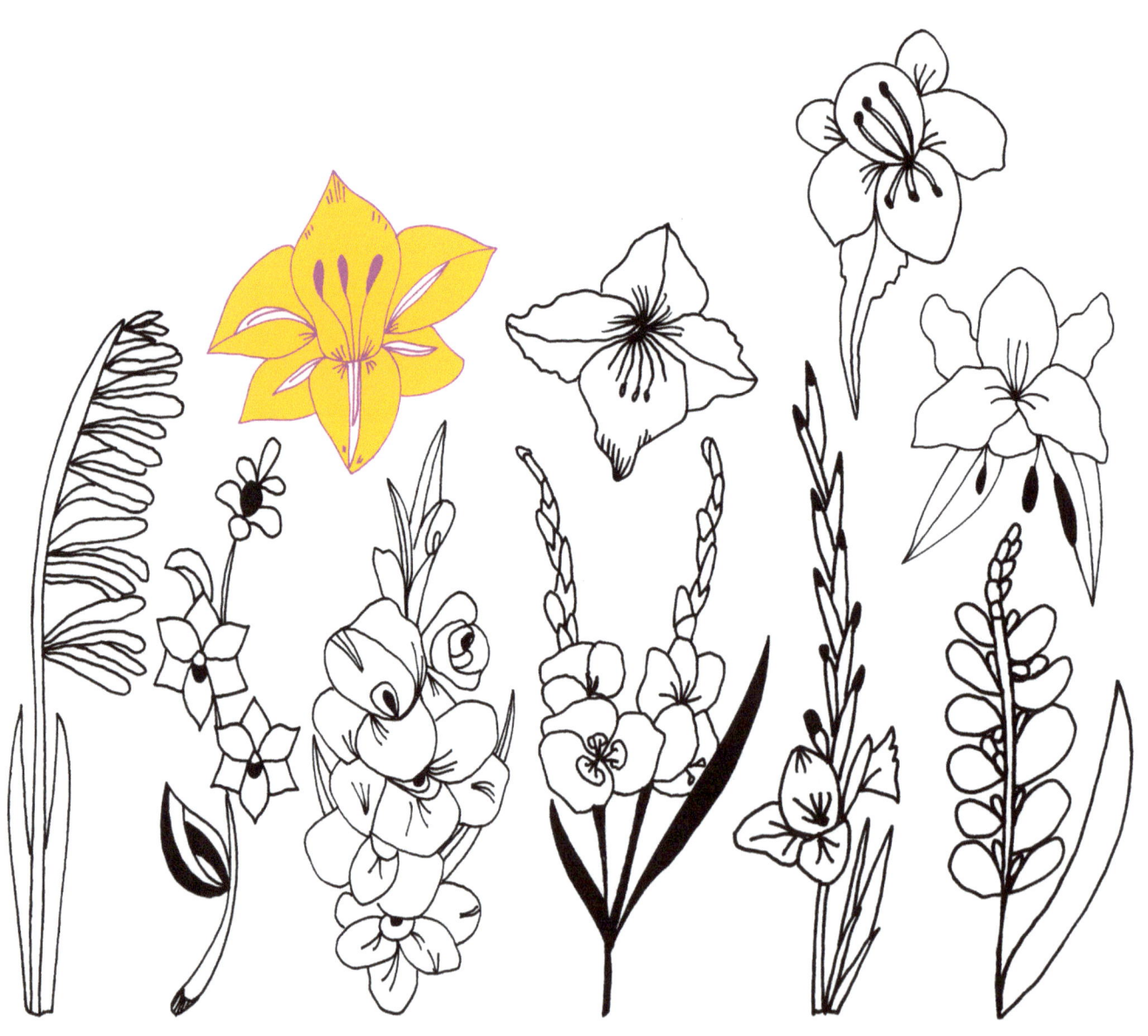

DRAW 20
Gladiolus

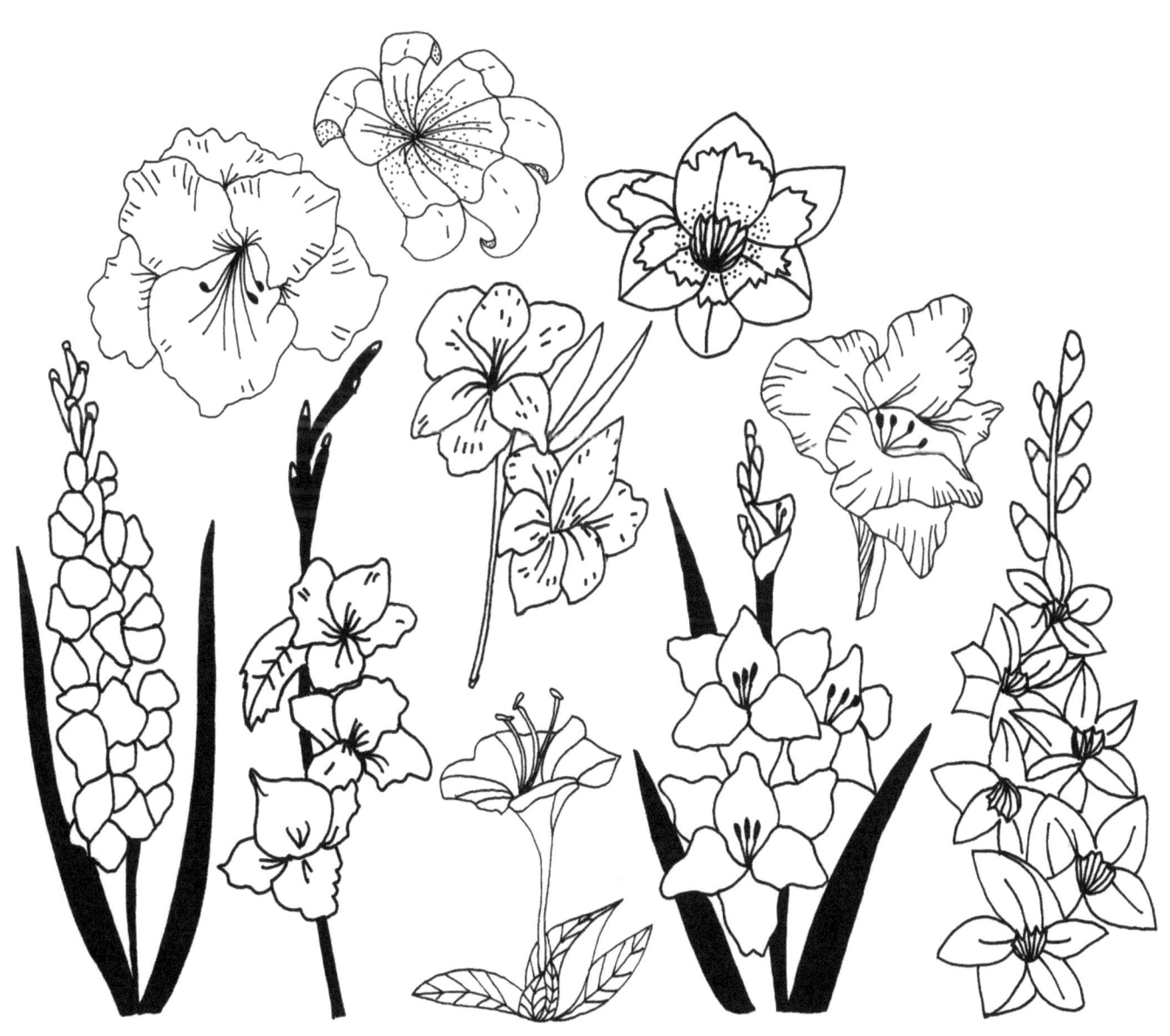

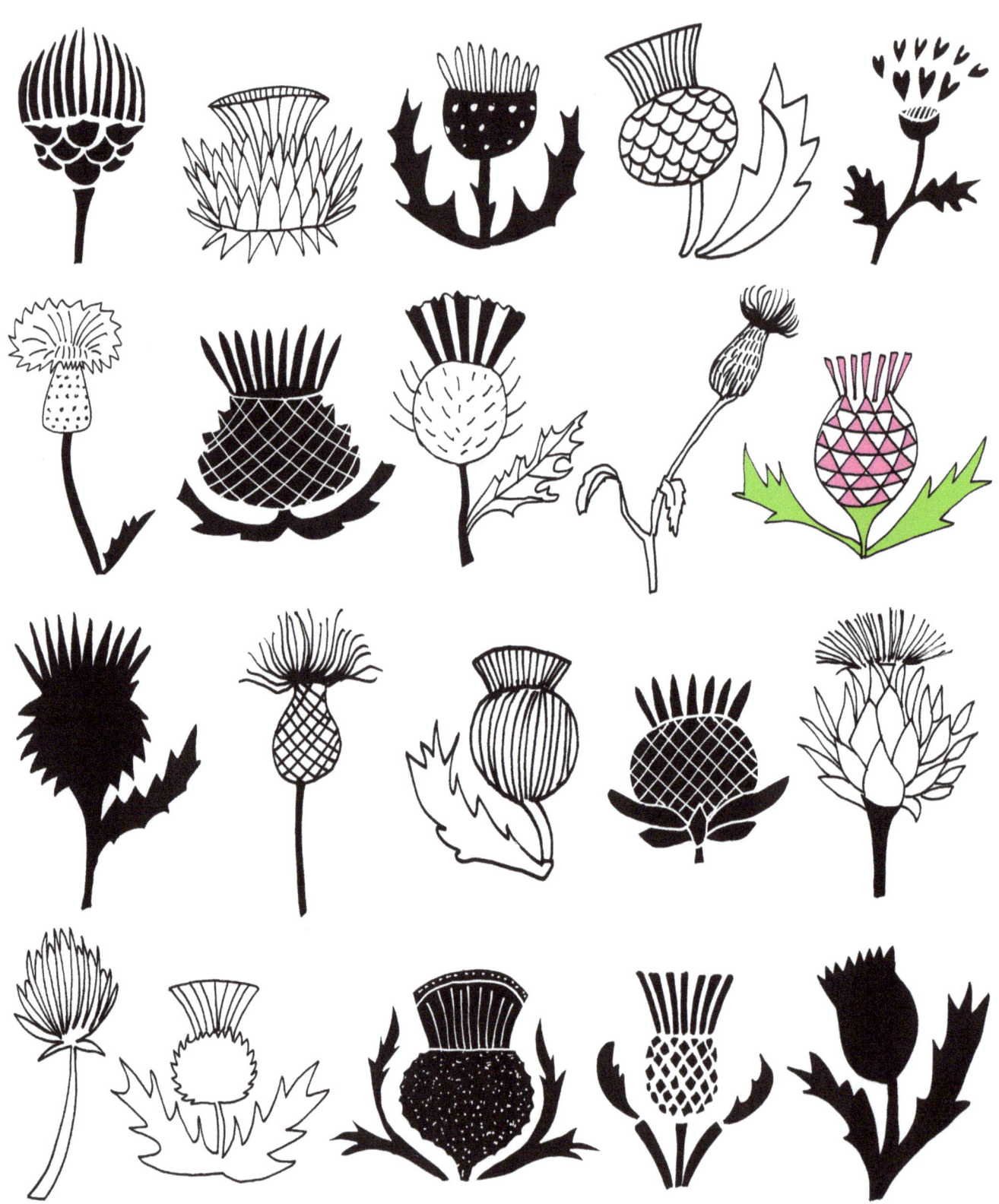

… DRAW 20

Thistle

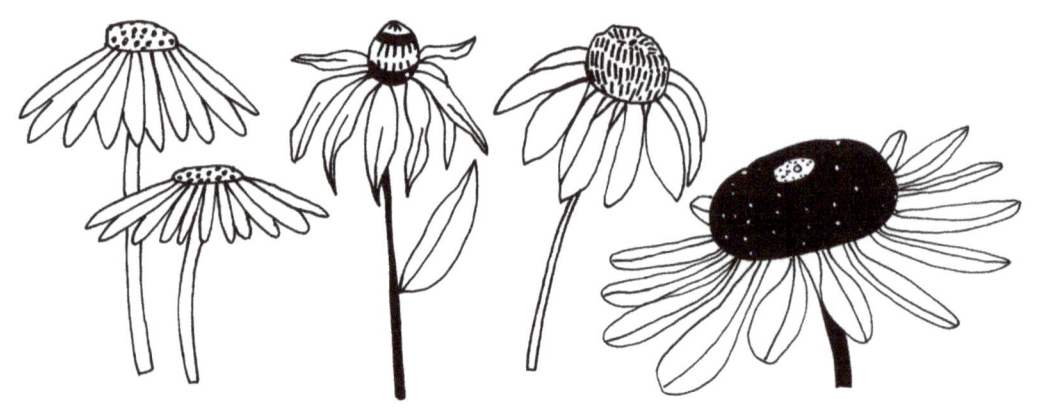
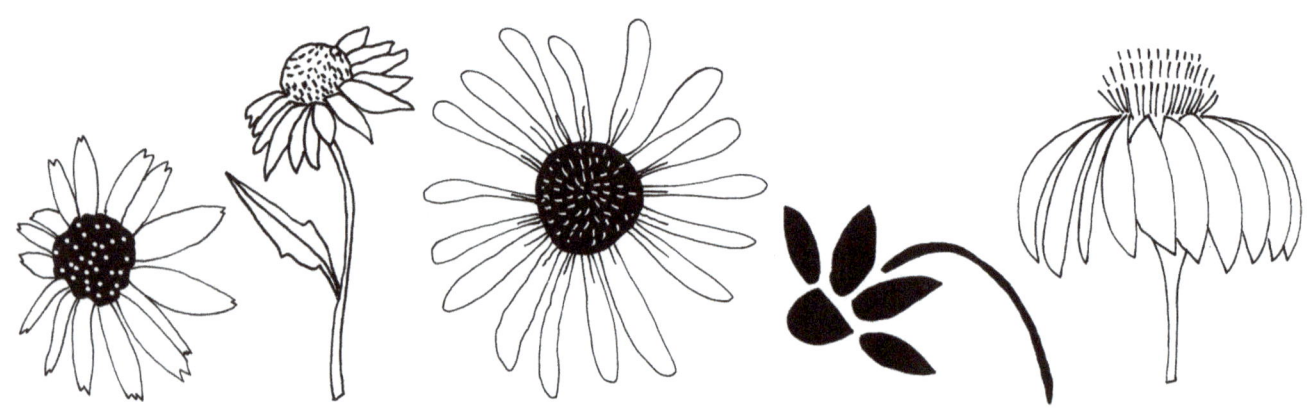
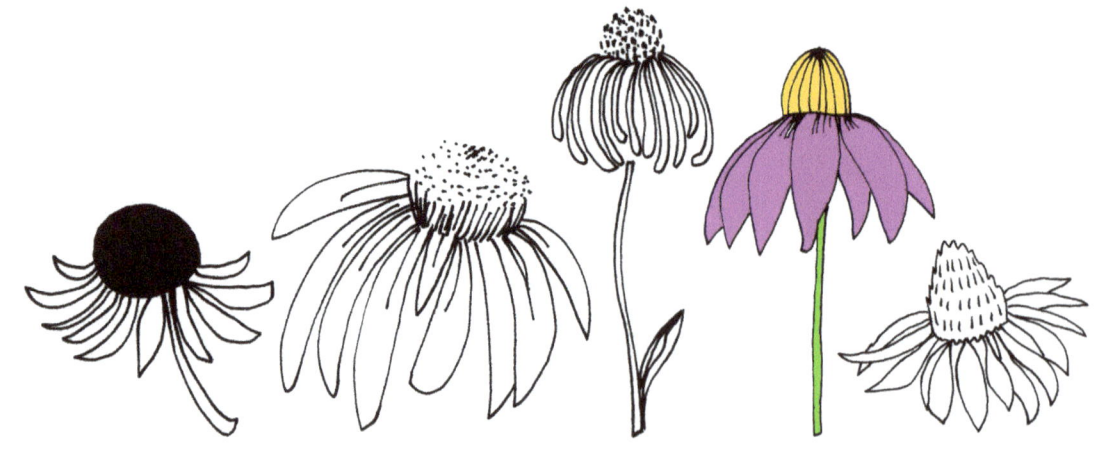

DRAW 20
Cone Flowers

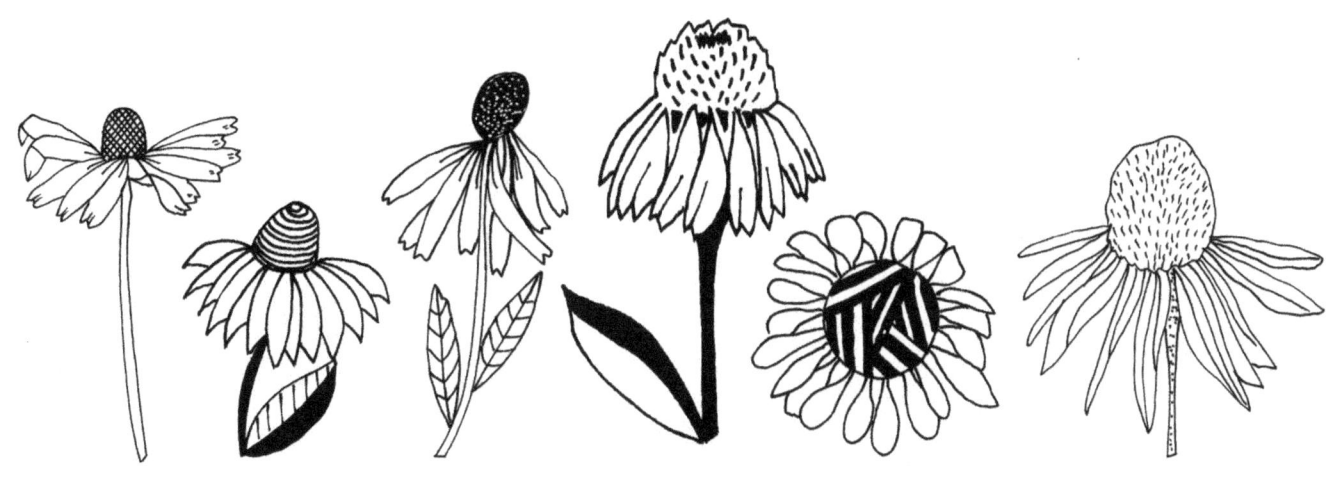

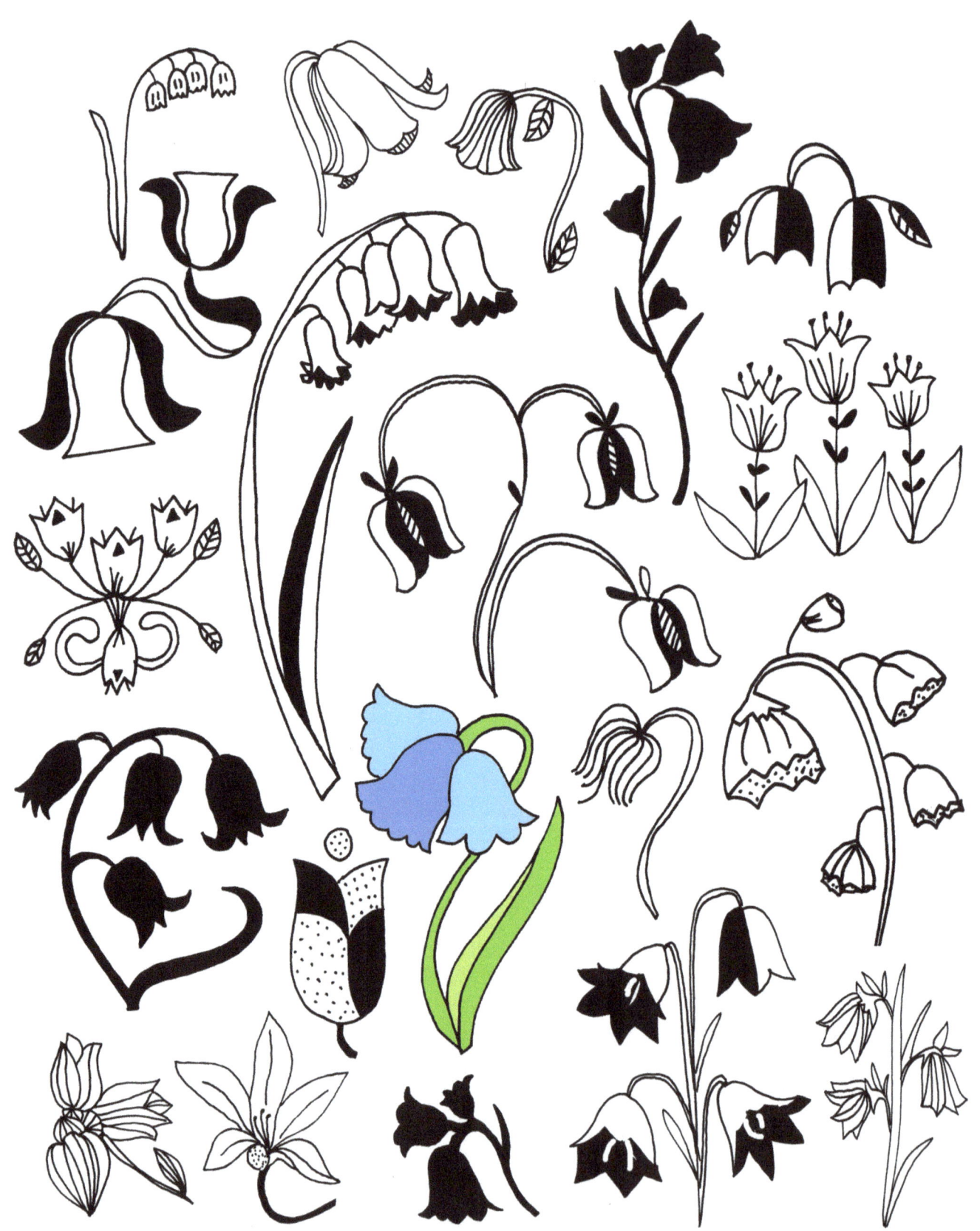

DRAW 20
Bluebells

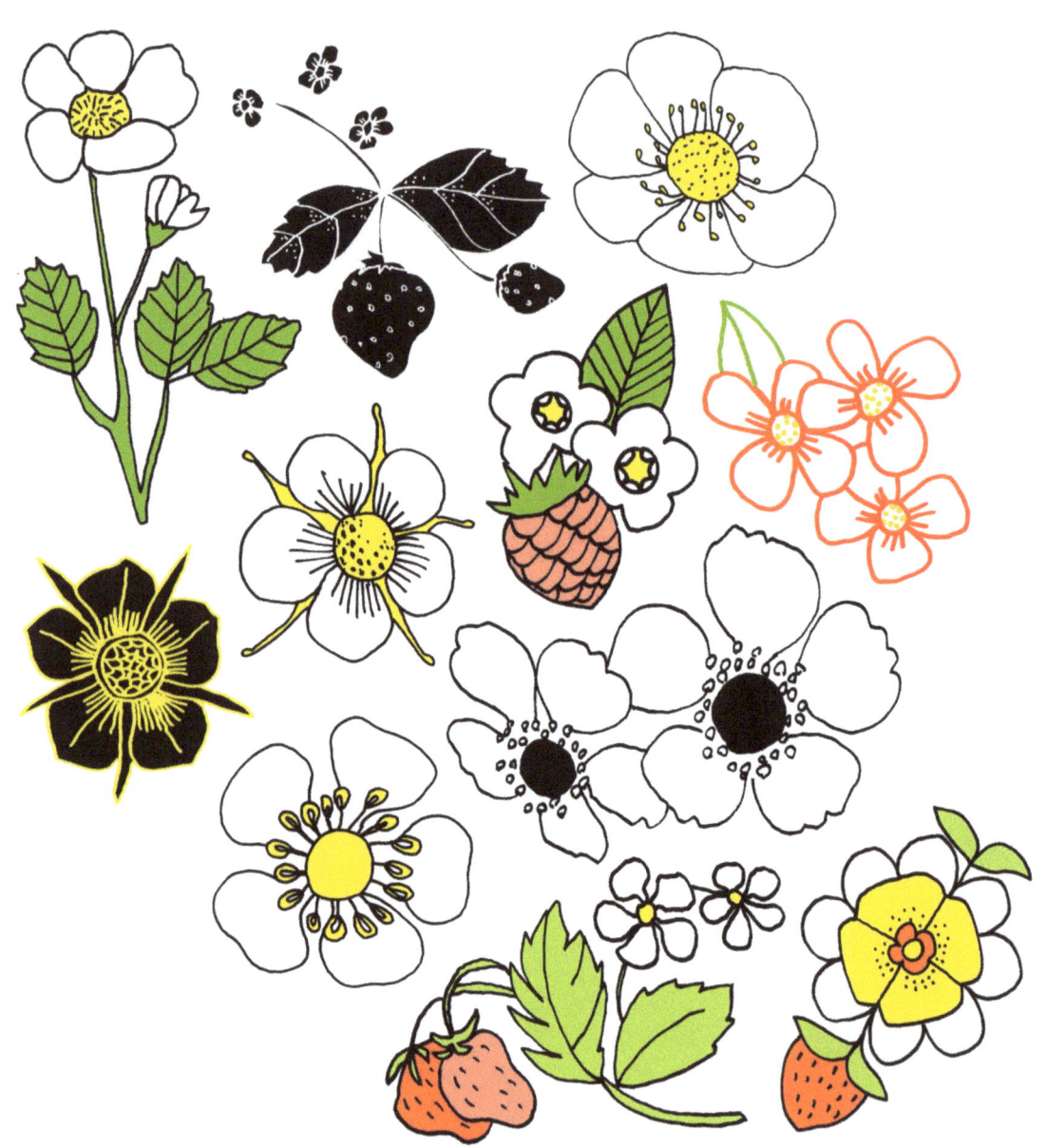

DRAW 20
Strawberry Plants

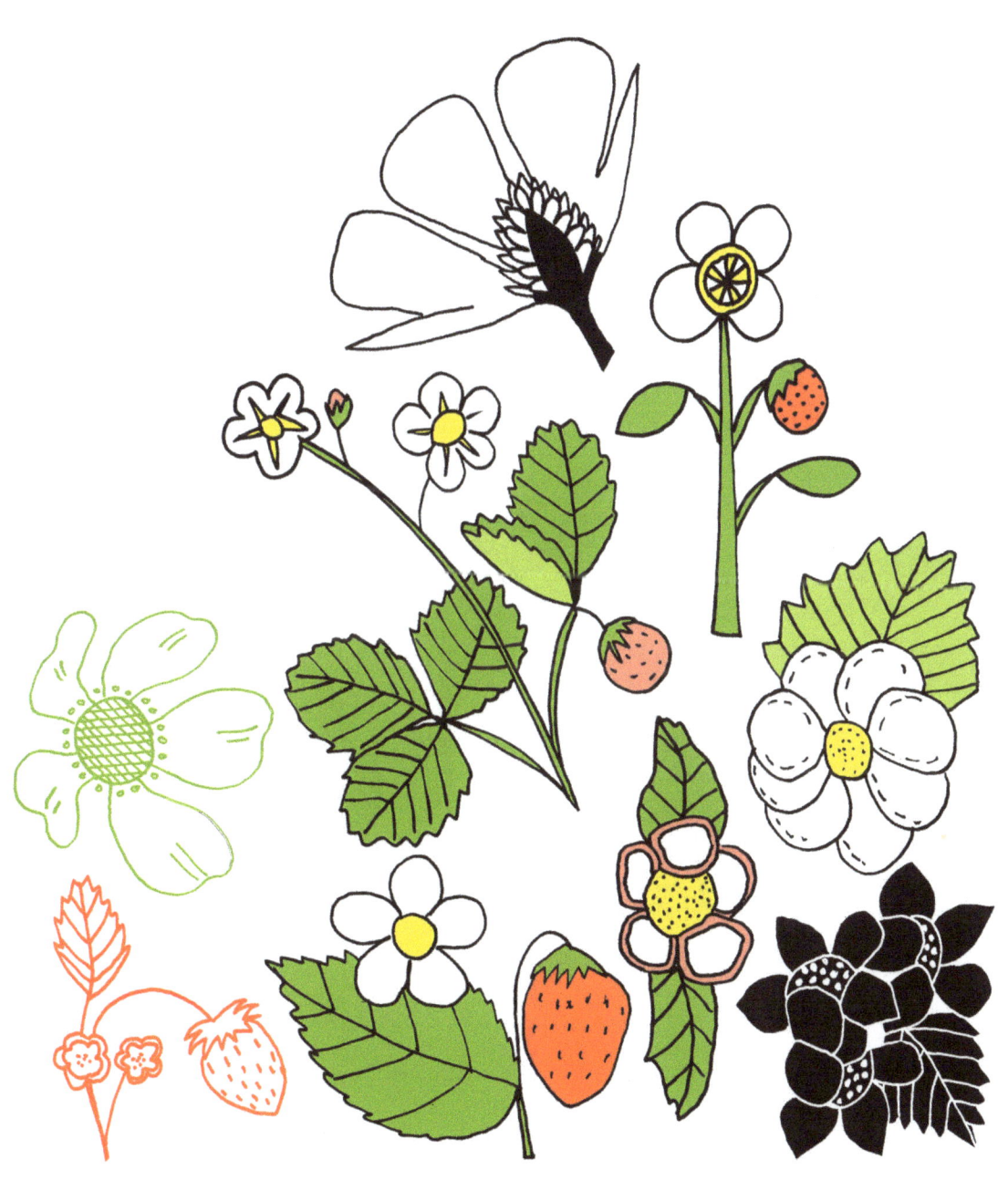

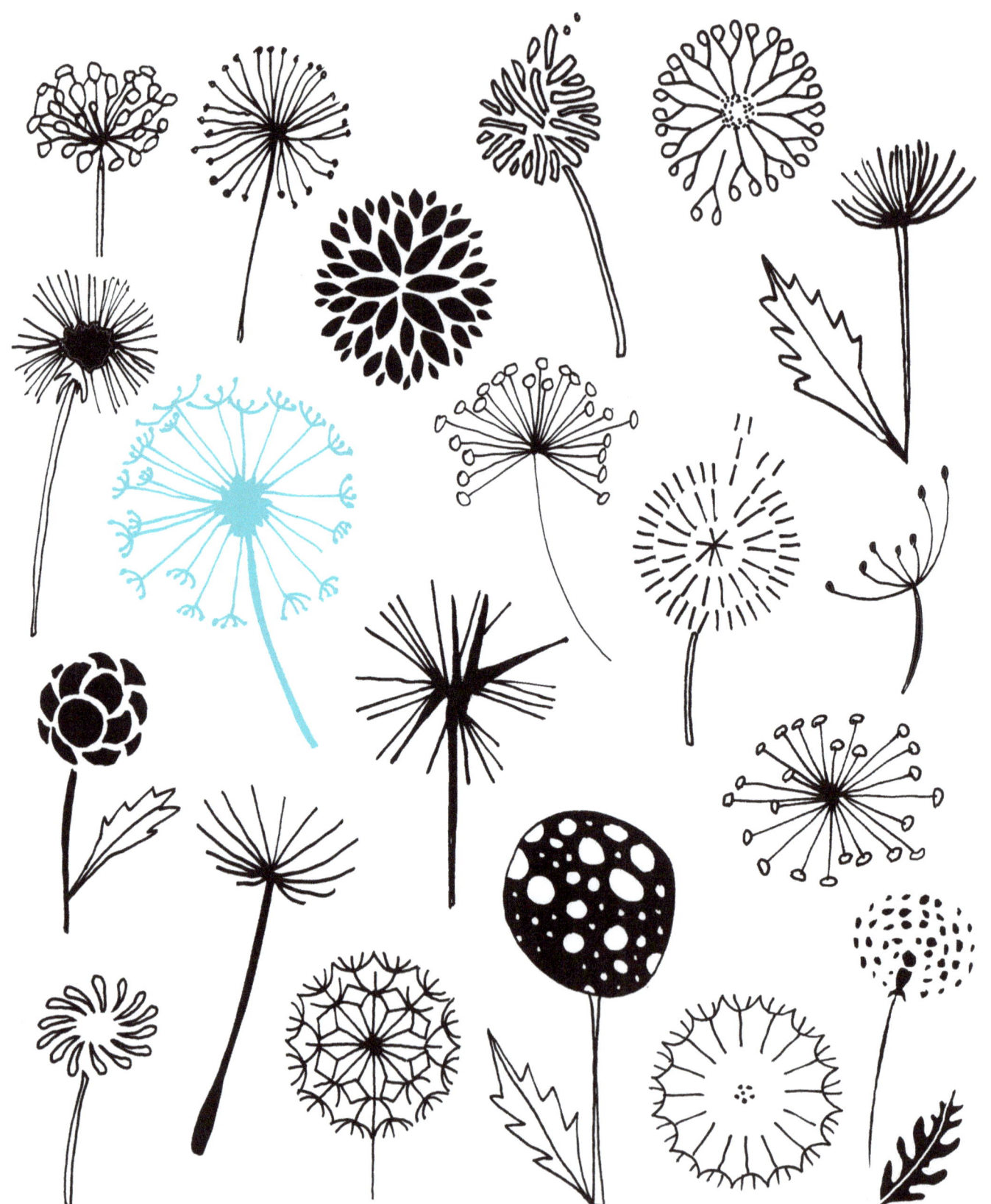

DRAW 20
Dandelions

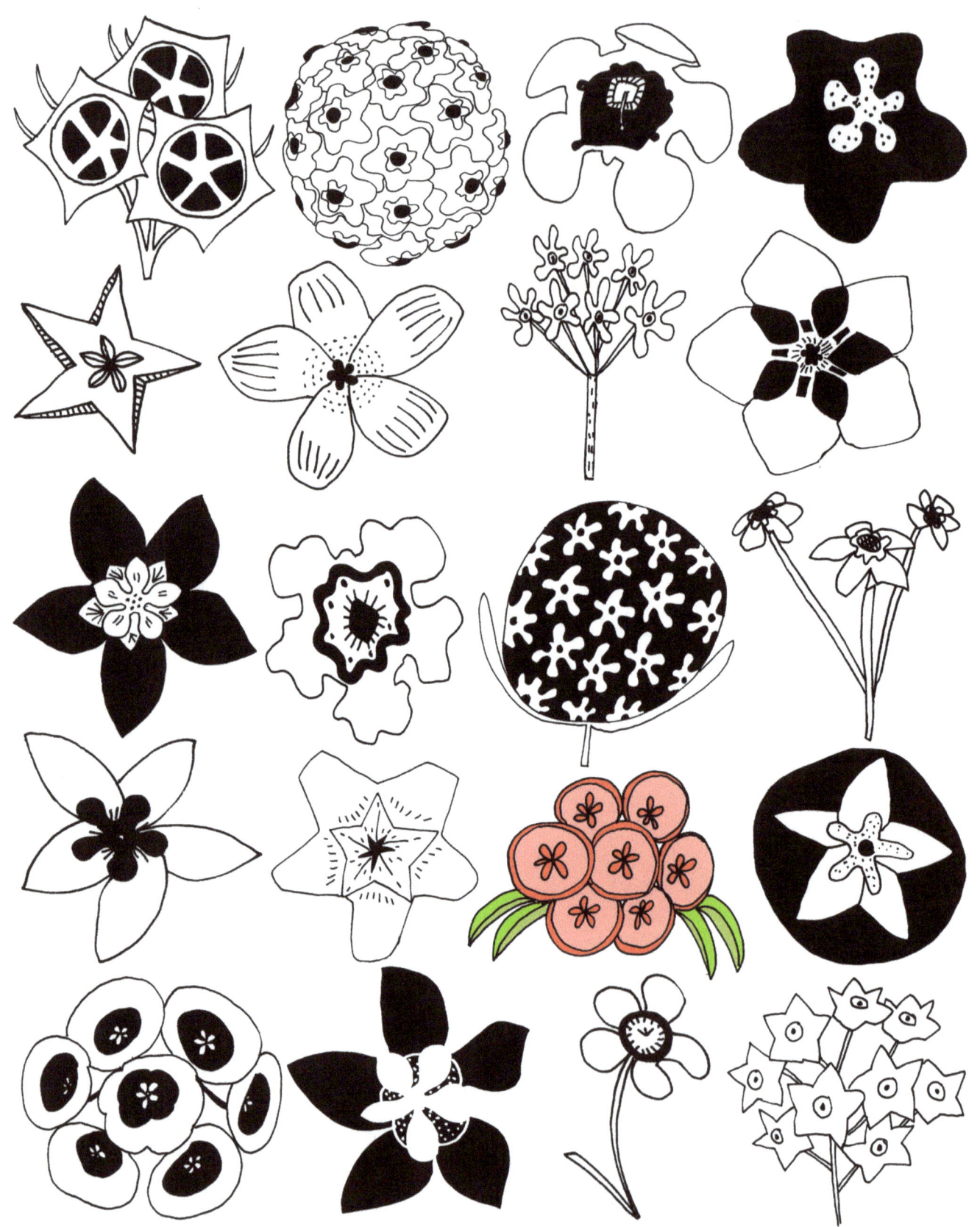

DRAW 20
WAX PLANTS

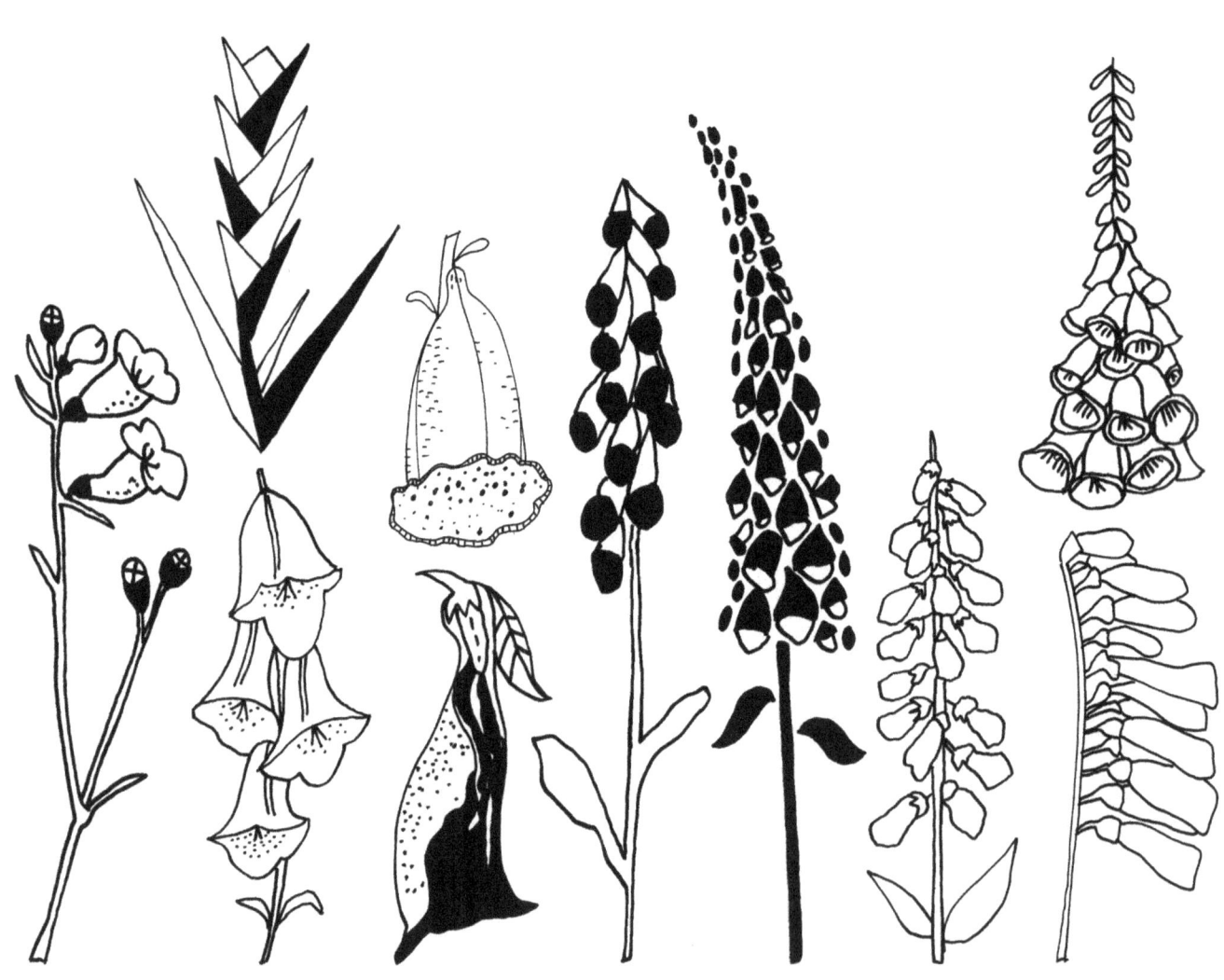

DRAW 20
Foxgloves

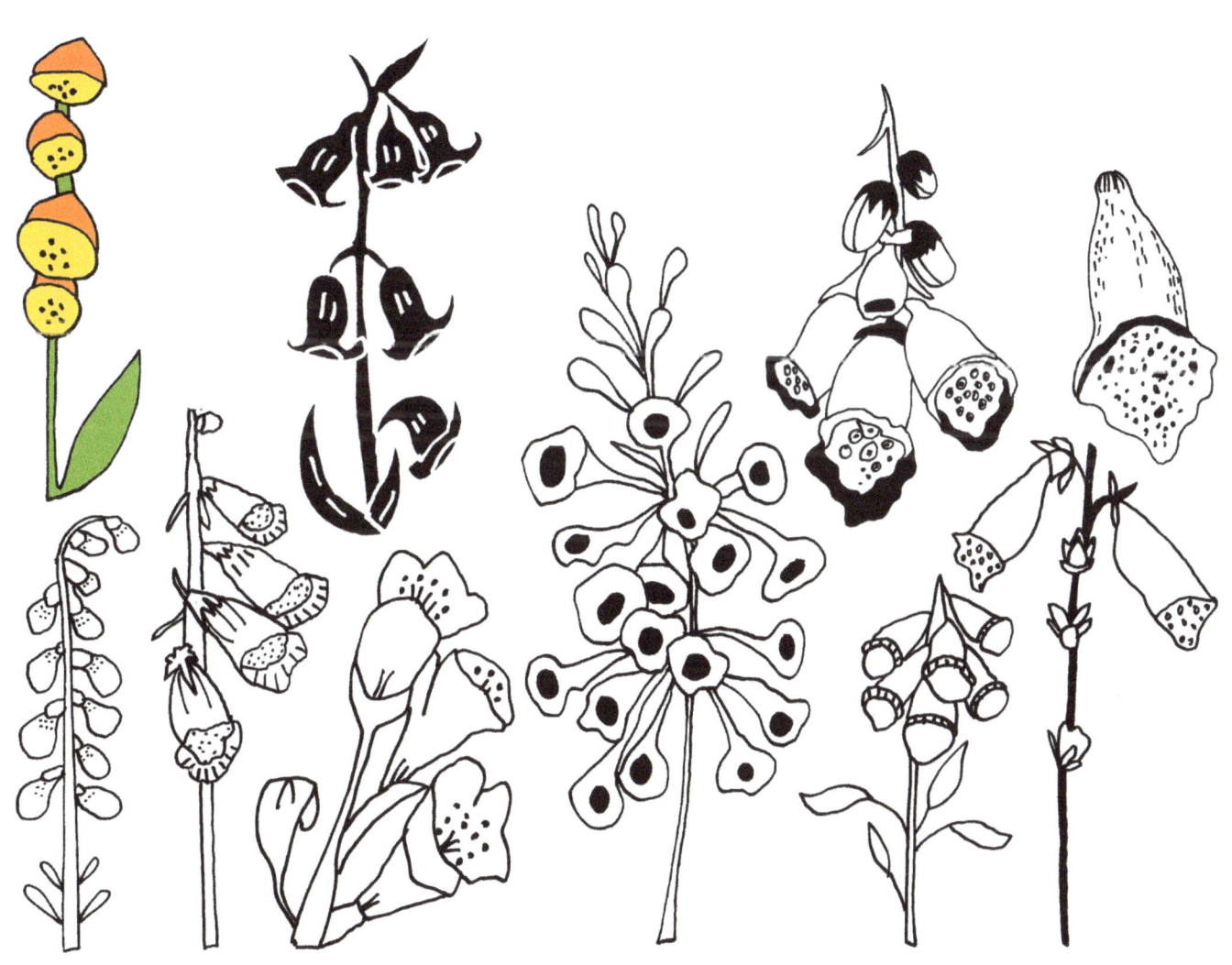

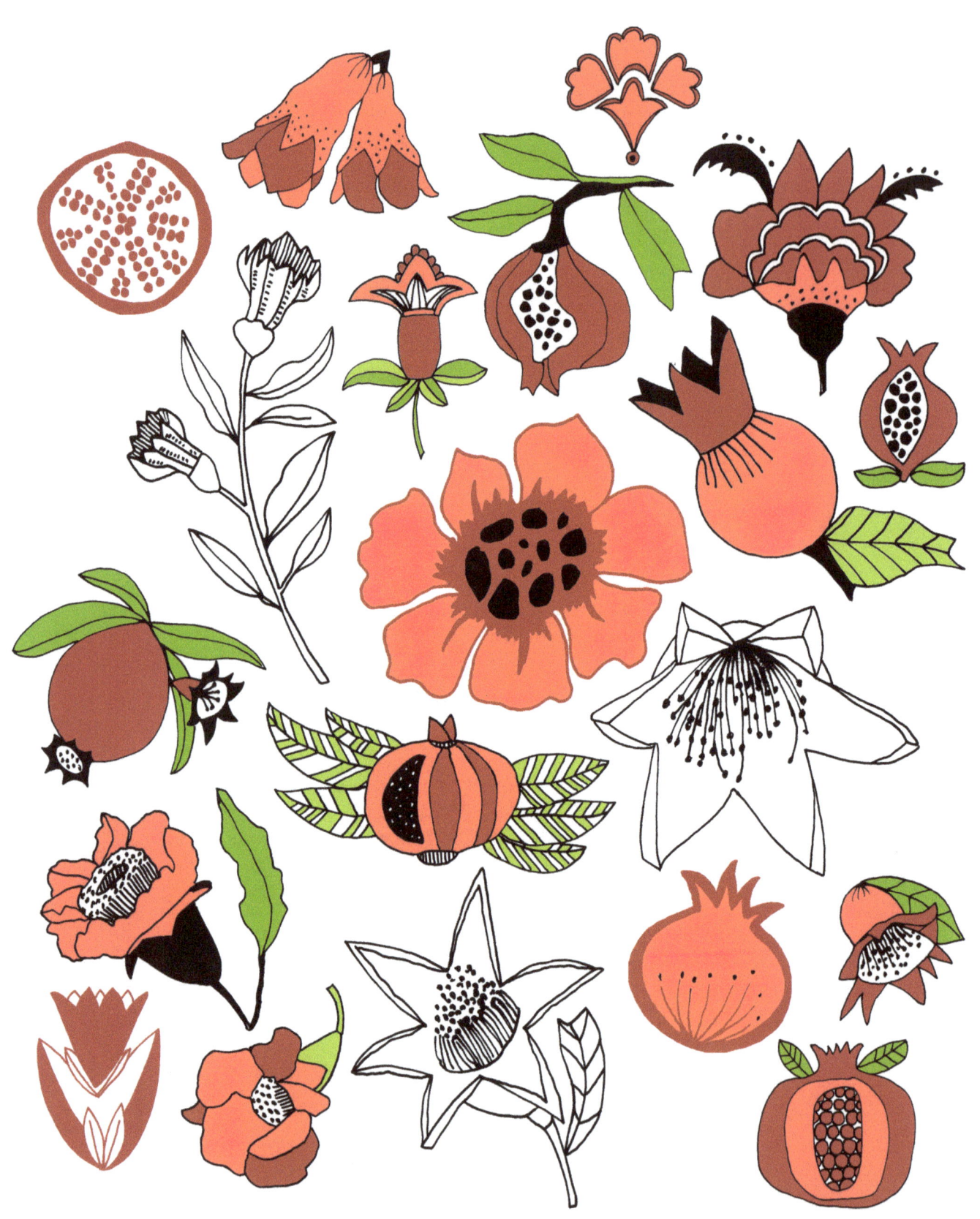

DRAW 20
Pomegranate Flowers

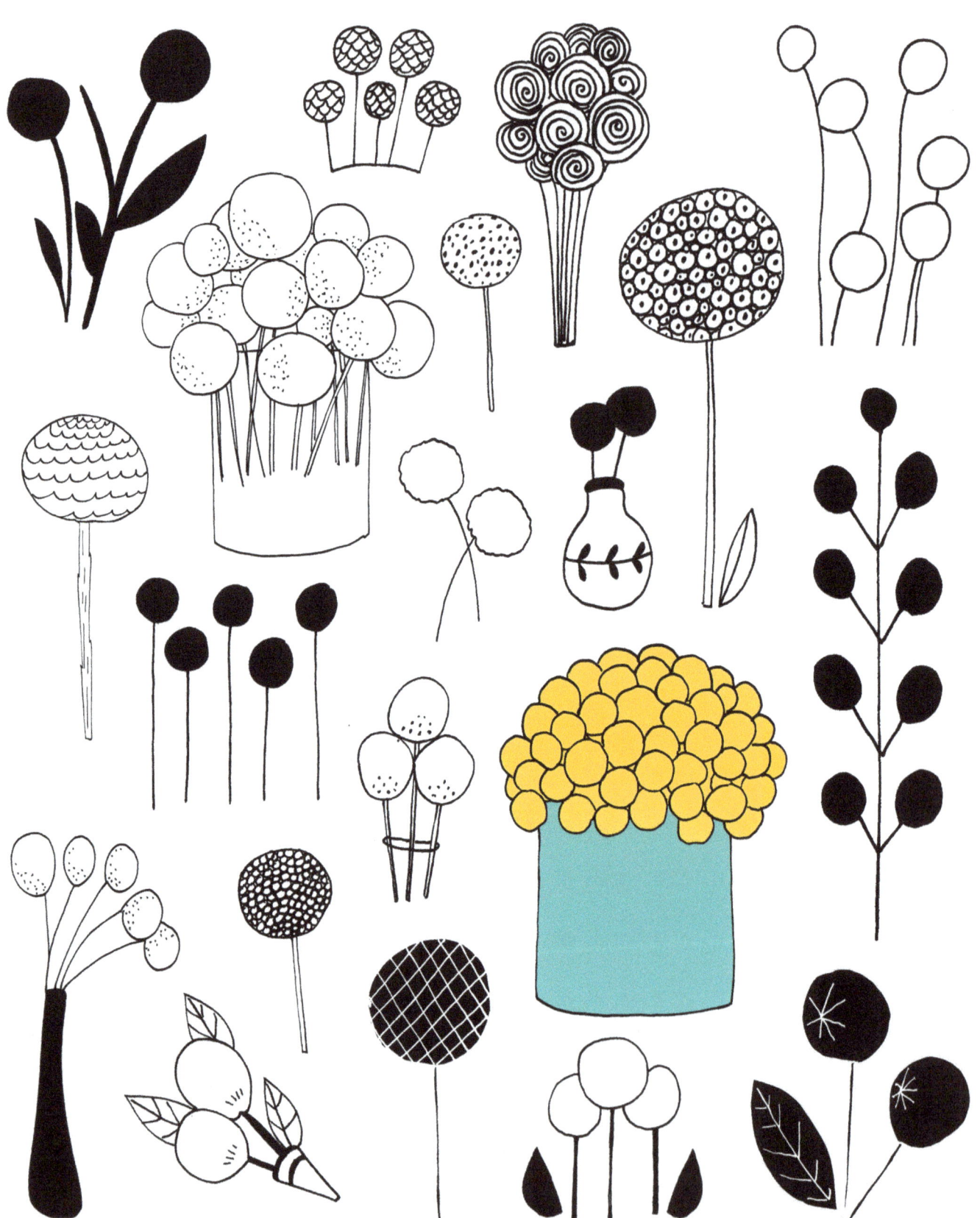

… DRAW 20

BILLY BUTTONS

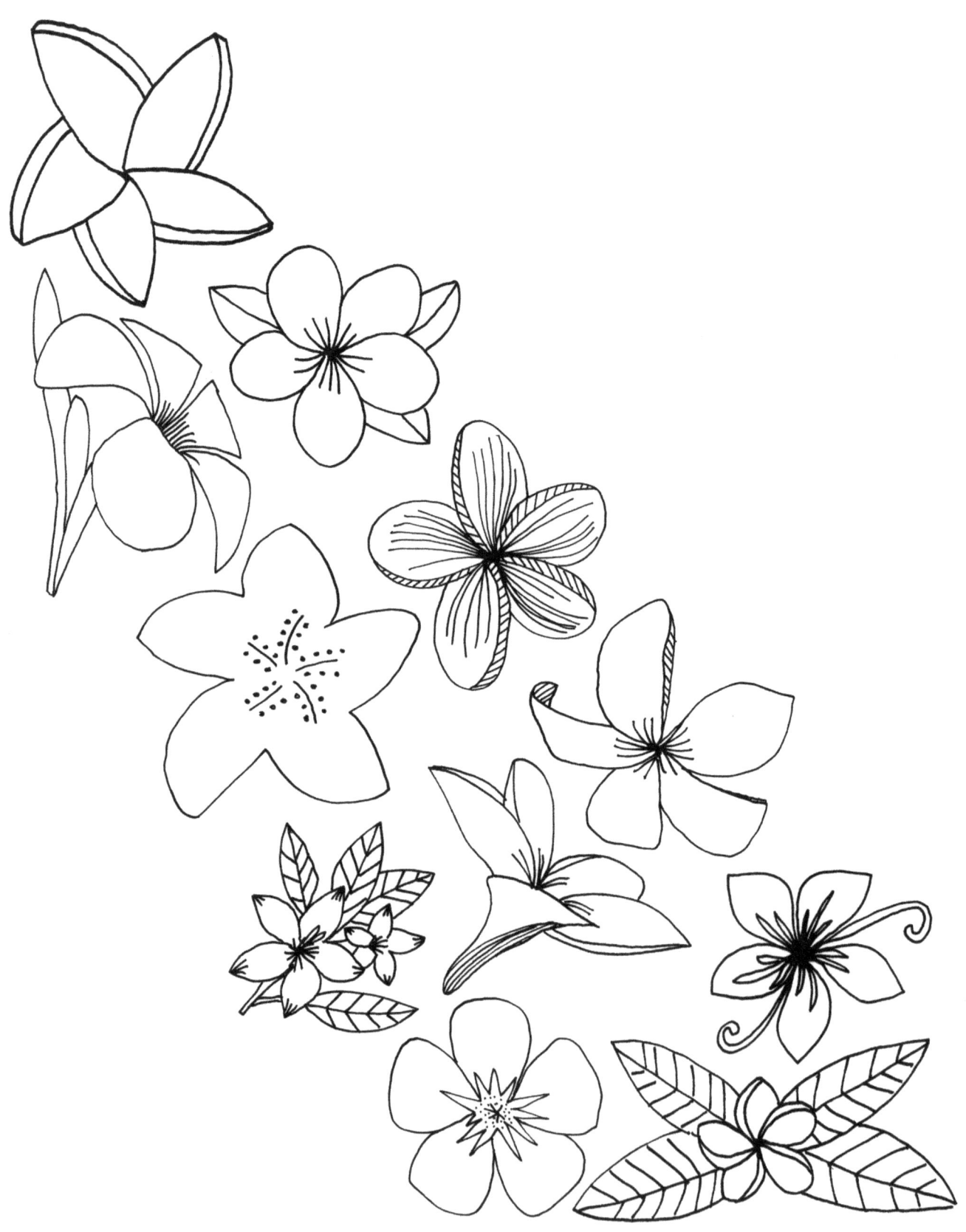

DRAW 20
Frangipani

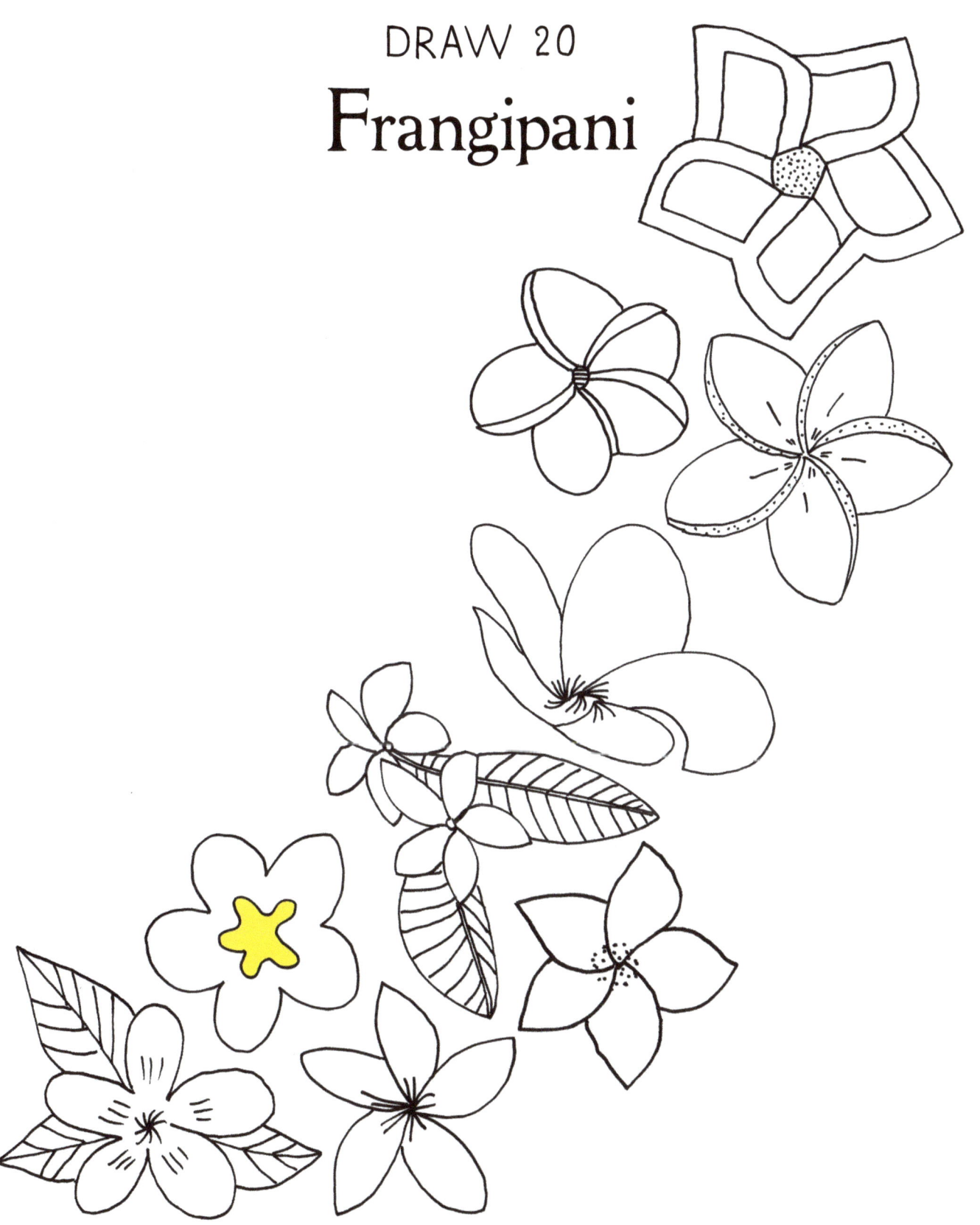

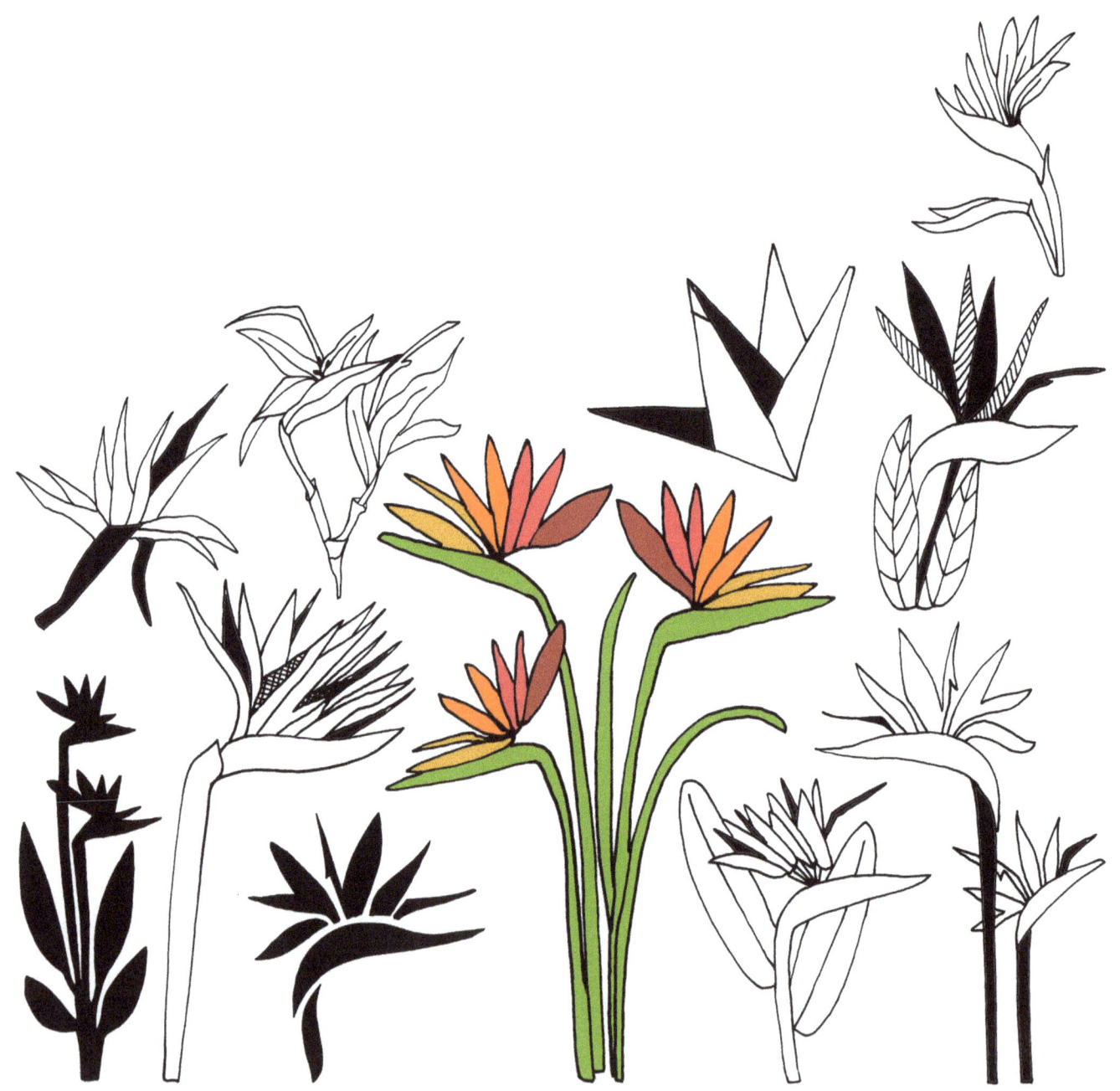

DRAW 20
Birds of Paradise

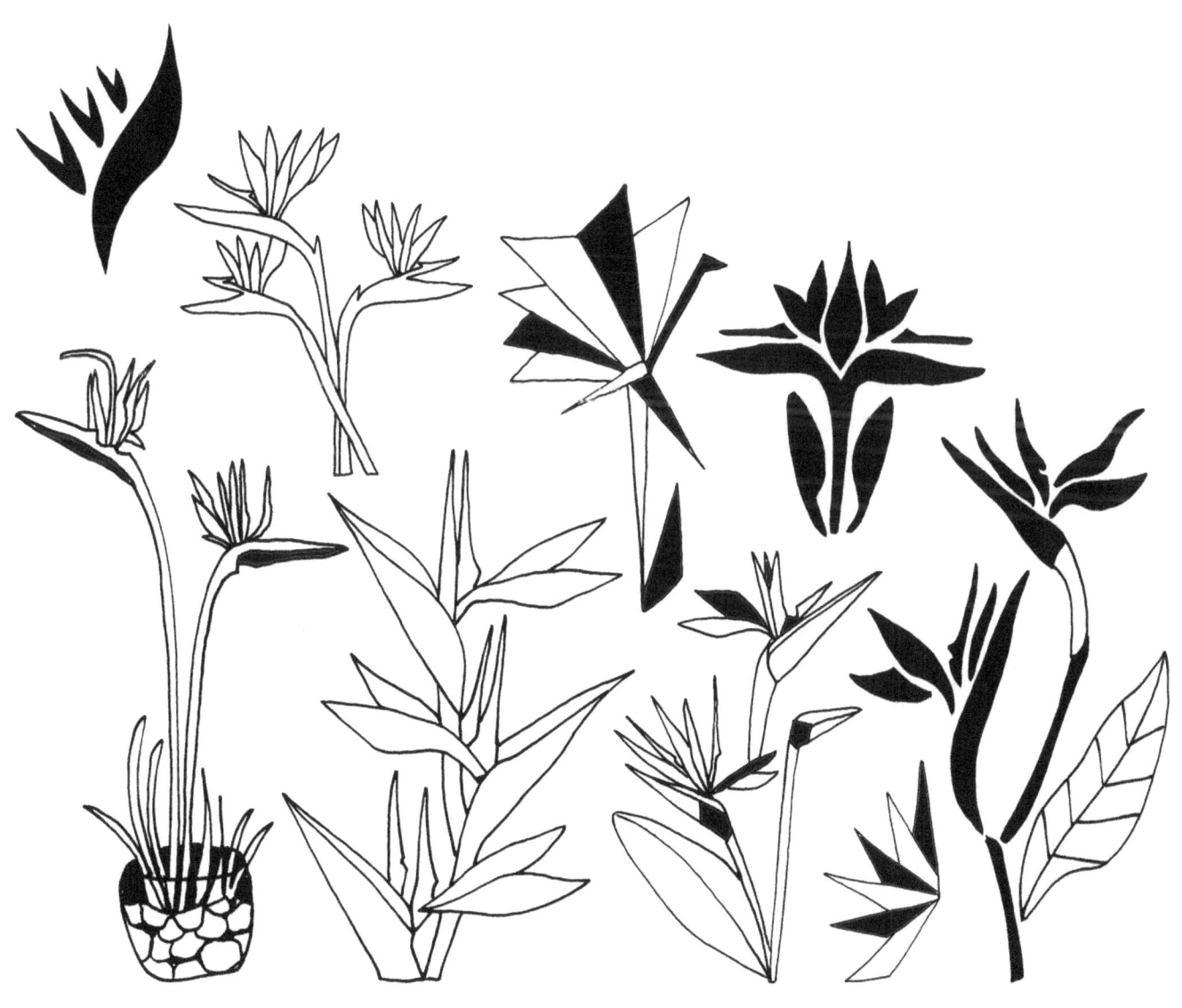

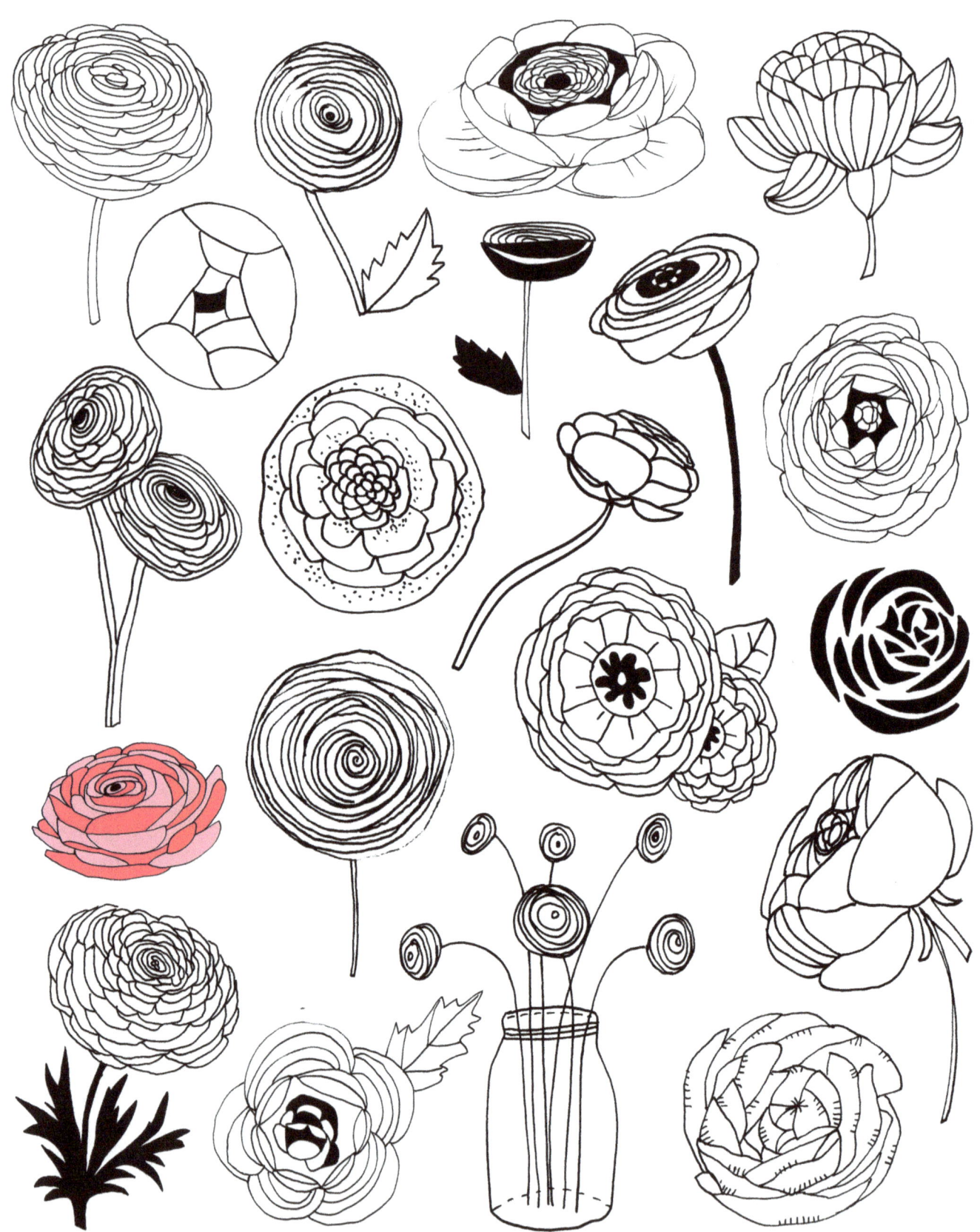

DRAW 20
RANUNCULUS

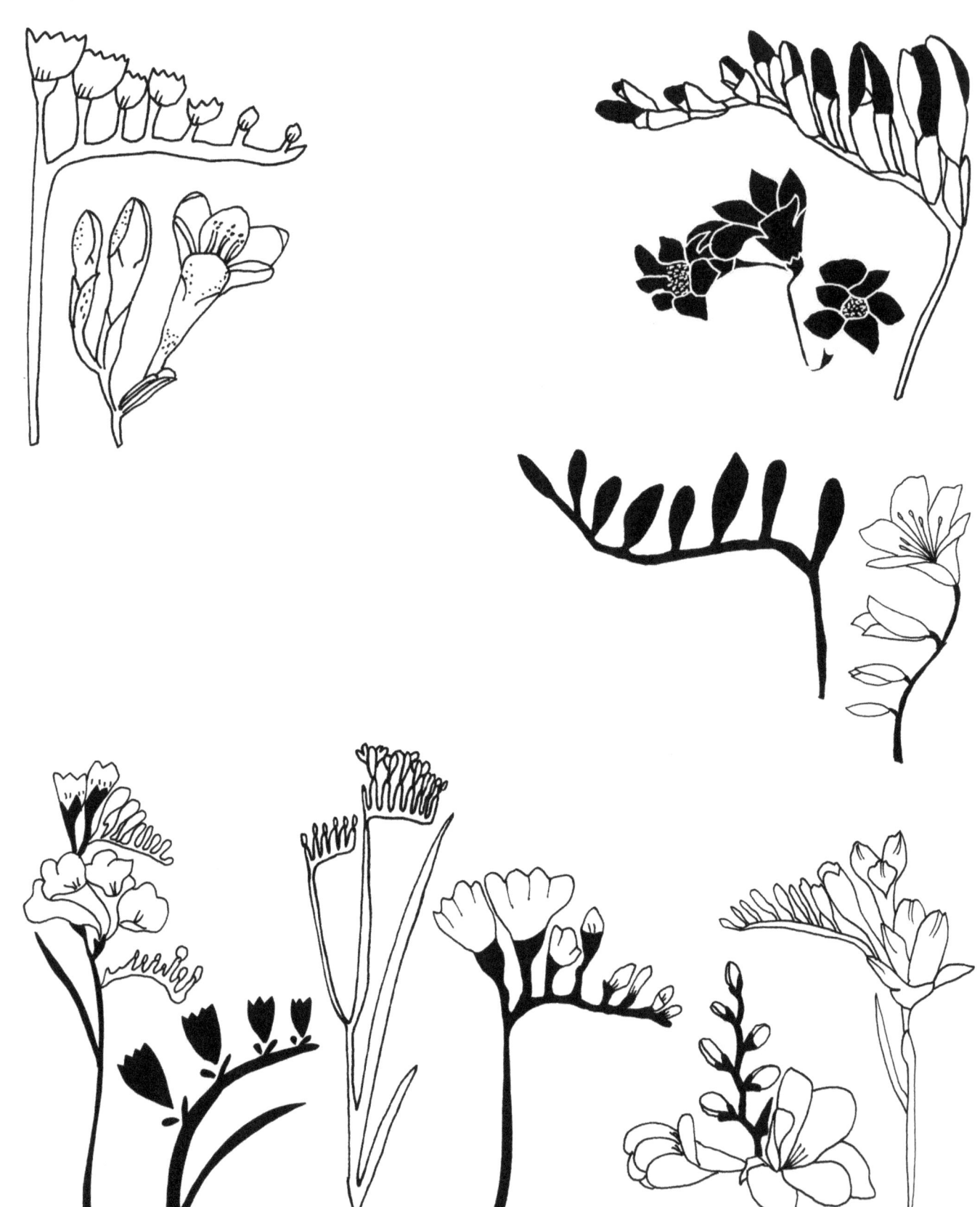

DRAW 20
FREESIA

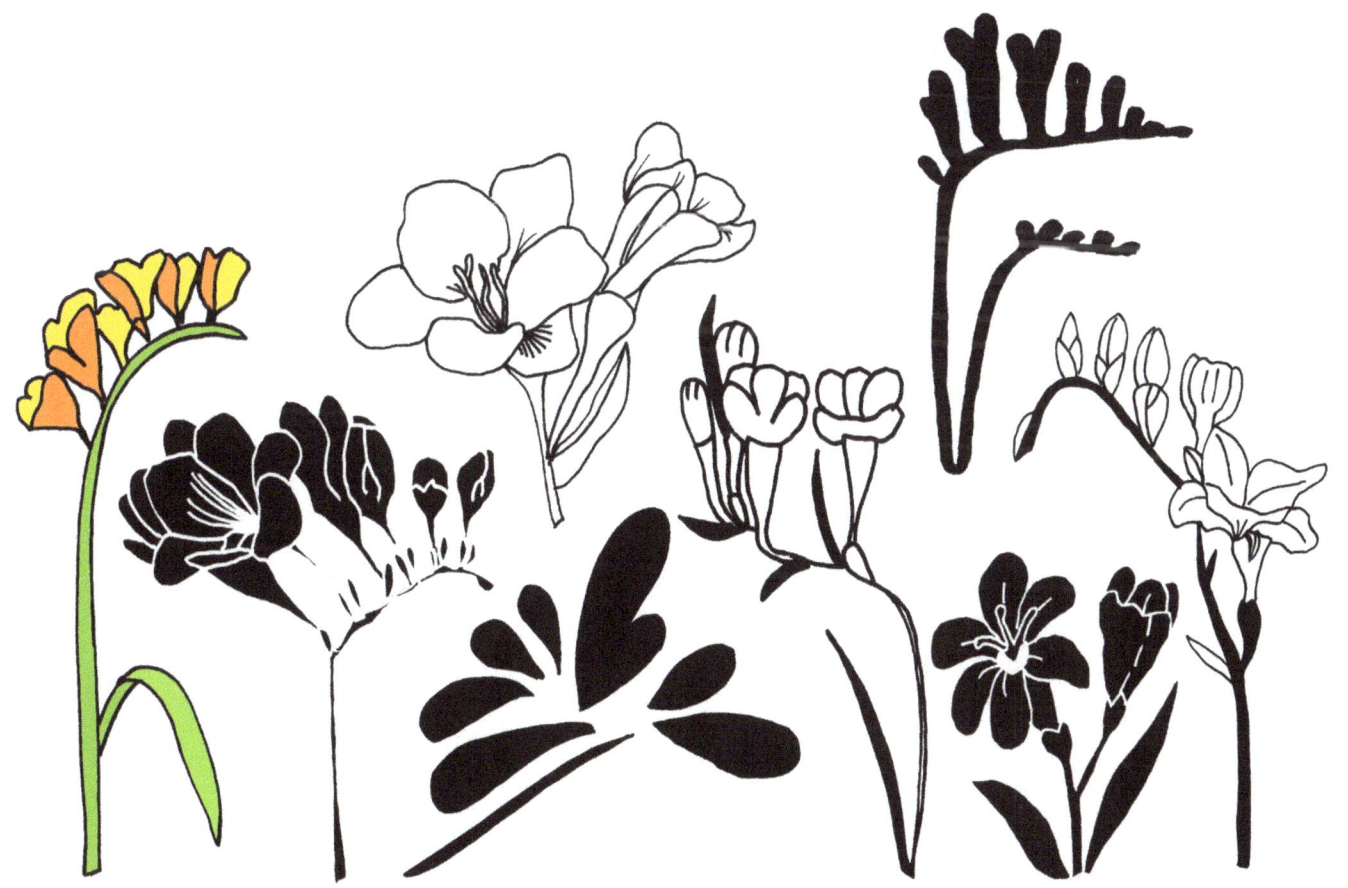

ABOUT THE ARTIST

Fine artist and illustrator Lisa Congdon is best known for her colorful and detailed paintings and drawings. She enjoys hand lettering and pattern design, and keeps a popular daily blog about her work and life called "Today is Going to be Awesome." Lisa's clients include Quarry Books, Chronicle Books, Simon & Schuster, and the Museum of Modern Art, among others. She lives and works in Oakland, California. To see more of her work, visit Lisa's website at **www.lisacongdon.com**.